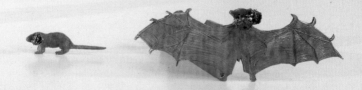

KIKI SMITH

KIKI SMITH
ALL CREATURES GREAT AND SMALL

Edited by Carl Haenlein

With a text by Carsten Ahrens

Kestner Gesellschaft
Scalo Zurich – Berlin – New York

This exhibition is
to celebrate

Elsa
Frangipani
Fritz
Jovan
Leonard
Lilith
Marlon
Mie
Philippa
Stella

Kiki Smith

ON THIS EXHIBITION

The Kestner Gesellschaft's exhibition *Kiki Smith — All Creatures Great and Small* shows the work of one of the most outstanding artists of our time. Kiki Smith, born in Nuremberg in 1954, first received international attention with her sculptures and drawings of the human body at the end of the 1980s. With her often provokingly direct images of human beings in which she shows the vulnerability of the physical, Kiki Smith won back a subject for contemporary art that some people had already considered to be lost.

In the course of the last few years Kiki Smith's work has undergone a constant process of transformation. In addition to her central theme of the human body, since the beginning of the 1990s the artist has created works where she shows the phenomena of our environment, the world of animals, landscapes, stars and planets. Kiki Smith uses these elements to form her poetic territories and to tell us about the dreams and nightmares of our age.

For the first time the exhibition in the Kestner Gesellschaft, which was conceived in close cooperation with the artist, unites works from different periods which Kiki Smith relates to each other in a mise-en-scène specially designed for the art institute's space. Once again the new rooms of the Kestner Gesellschaft have proven their versatility.

The present catalogue documents the exhibition at the Kestner Gesellschaft. We wish to thank photographer Attilio Maranzano

who as in our Rebecca Horn exhibition documented this show with excellent pictures. Using a number of iris prints from the past year Kiki Smith has put together a series of pictures which close the book. We wish to thank Kiki Smith for this contribution which was carried out in cooperation with Hans Werner Holzwarth. In particular we would like to thank her for the wonderful time we had working together with her at the Kestner Gesellschaft. We also wish to thank Denise Fasanello, Carl Fudge, and Joey Kötting, Kiki Smith's assistants, who were a great help in the preparation of the exhibition.

The Kestner Gesellschaft would like to thank the galleries and collectors whose loans made this project possible; we would also like to thank them for their active assistance in all organizational questions. In particular we thank Susan Dunne and PaceWildenstein, New York, Mark Fletcher and the Anthony d'Offay Gallery in London, the Barbara Gross Gallery in Munich as well as the Goetz Collection, Munich.

Our special thanks goes to the Land of Lower Saxony for its support of this exhibition.

<div align="right">C. H.</div>

ALL CREATURES GREAT AND SMALL

KIKI SMITH'S ARTISTIC WORLDS

Carsten Ahrens

What beauty is I do not know,
although it is attached to many things.
Albrecht Dürer

A dream is like an animal, but an unknown one,
and you cannot see all its limbs. Interpretation is a cage,
but the dream can never be found inside.
Elias Canetti

One cannot imagine how multi-layered the artistic worlds are that Kiki Smith has been producing for two decades. In an apparently inexhaustible diversity of forms her work mirrors a world which has fragmented into a multiplicity of marvelous, graceful and shocking phenomena. Like a rainbow which refracts the glaring white beam of sunlight into a spectrum of colors, Kiki Smith's works construct an image of the world that unites the fragmented experiences of our time. It is an image that is permeated by the utopia of a harmonic whole but where the wounds and fractures of human existence and the desires and contradictions of our time remain, become tangible even.

In the form of a polyphonic song Kiki Smith articulates an alternative world that is both poetically tuned and dramatically

heightened, a world which crystallizes out of the perception of our present. The crucial point of this work, which appears to grow organically on circular orbits, is the belief in a *via regis* to human existence, the confidence in the potential of a comprehensive experience that covers all aspects of existence. The question of how we perceive our existence and our surroundings becomes the decisive leitmotif of her art. How do we experience our body, what do the beings and things mean that we are surrounded by, in what way do they define the images that we have of the world, and in what way are they part of the configurations within which our identity is formed — these are the questions on the basis of which the work sets its course.

In the course of her research Kiki Smith embraces a large spectrum of artistic techniques and materials which often go back to past epochs, forgotten in fields which apparently have no connection with the modular concepts of modern art. But there is nothing which is foreign to the nature of Kiki Smith's work; everything, be it substance or content, might be potential material for an art which makes fruitful use of what belongs to the past for its present subjects.

Thus her works are created in such diverse materials as paper, terracotta, bronze and ceramics, video and neon, glass, porcelain, cloth, wax or cellulose; she employs techniques that she discovers during her explorations in the world's historic museums and when studying past epochs. That is when she also discovers mythological themes from long extinct cultures in which images are mirrored that human beings continue to develop of the world over and over again.

However intricate these very formal narratives, put in the language of contemporary art, might be, we always recognize images of woman and

man, of their bodies, of their ideas, experiences and utopias, of their sufferings and hopes, of their fables, myths and fairytales, of their dreams and nightmares.

What at first sight is astonishing about Kiki Smith's work is that it combines the two apparently diametrically opposed poles of art in the 20th century, figuration and abstraction. In the poetic areas of her art the narrative richness of figurative representation marries the cool rigor of formal abstraction. The customary boundaries of art become blurred, even disappear completely in this work, which neither knows nor admits any boundaries.

This lack of boundaries is especially true of the thematic focal points of her work. When in the mid-1980s Kiki Smith received increasing international attention with her shocking views of the human body, mainly the female body, her art was quickly labeled "body art." In blatant directness her sculptures presented us with the elements which go to make up the human body. Apparently Kiki Smith's interest was in bodily phenomena which we usually suppress and which are not given any space on the glossy glamour pages of our time. Her interest was directed towards bodily fluids and organs which do not rhyme and combine, like heart and part, heart and pain, but are called liver, kidney and bile, saliva or sperm. But her thematic approach had deeper artistic motives than just provoking and shocking the viewer.

"I think I chose the body as a subject, not consciously, but because it is the form we all share; which we all know from our own experience." [1]

This basic approach of authentic experience has remained the same up to the present, even if her work has continually changed in terms of its subjects, forms and materials. Like a process of metamorphosis, one

apparently emerged from the other. Step by step Kiki Smith described an imaginary voyage — that is from the inside of the body to the surfaces of the world, towards complete figures and their surroundings. In this way figures were created that on the one hand told us about the vital energies of the inner body and that on the other hand became emblematic images of human vulnerability. The vulnerability of the body, its wounds, scars and lacerations, became metaphors for the fragile nature of our consciousness. Over and over again Kiki Smith played with the delicate balances between the inside and outside in this way. She tattooed the soul's injuries of our time on the figures' bodies and presented them as the embodiment of spiritual processes.

Kiki Smith has repeatedly described this approach and in this context she has continually hinted at the close proximity between art and the ideas of Catholicism, which are similar in their belief in the spiritual potential of the physical. "Catholicism has the idea of the host representing the body. Catholicism is continually concerned with the physical manifestation of bodily phenomena; it changes inanimate things into vehicles of meaning." [2]

To a large extent because of these contexts Kiki Smith's interest turned to those anthropomorphic idols in which the world views of the history of humankind are mirrored, the protagonists from the myths and religions of different cultures. These embodiments of the conceptions of the world allowed the world itself with all its phenomena to gain entry into the work. Since the beginning of the 1990s she has created drawings and sculptures of animals, of continents, of crystalline forms, of stars and the moon. Kiki Smith explores what

the phenomena of the world might still mean to us in an age of media networking and of conditioned perception. She studies the ways in which our identity is bound to the phenomena of our natural environment or how our imagination is formed, for example through the numerous images from the animal kingdom that pervade our fables and myths and even our everyday language. Thus the bird may appear as a metaphor of the soul as in *Getting the Bird Out* (1992) or as a memorial to the destruction of nature by human beings as in *Jersey Crows* (1995). With her Noah's Ark Kiki Smith outlines an atlas of vanishing significance, where all the creatures, the small and the great, make their appearance. *All Creatures Great and Small,* the title of her exhibition at the Kestner Gesellschaft, thus describes the program of an artist who creates the poetic charm of an artistic world from the fragments of our perception.

There is no question that the process of the work's evolution, which appears as a logical one in retrospect where it seems that one thing led to another, follows a more random dramaturgy which is characteristic of artistic research.

Kiki Smith discovered art in a roundabout way. It seems both surprising and logical because as the daughter of opera singer Jane Smith and artist Tony Smith she grew up in an artistic environment. Her parents' house was her father's studio. It was filled with abstract sculptural models that gave the house its atmosphere; it was a laboratory of minimal form.

From her early childhood Kiki Smith and her sisters Seton and Beatrice helped their father to produce paper models, tetrahedra or octahedra which served to try out possible forms of volumes in

space. While Seton Smith decided to become an artist as early as twelve, Kiki Smith had no ambitions of this kind, although from the very beginning she was fascinated with making things with her own hands. "I always liked making things, but I liked crafts more than art."[3] Up to today working with her hands has been a decisive category in her life; she appreciates it not only in the fine arts, but also in the less heroically admired applied arts. Here is one of the roots of Kiki Smith's love of decorative arts and of all forms of human creation, be they socially recognized or not.

It was thus by no means Kiki Smith's dream to become an artist. Beyond the narrow limits of art she imagined doing something in life that might change the world in a more direct way. At first the ideas of the hippie movement influenced her considerably. The desire to live a true life in intuitive purity, the idea of living in tune with nature fused into a dream of revolution. Its heroes were Mexican artists whose native art pursued a revolutionary mission that reflected the themes of their time.

So when she graduated from high school Kiki Smith went to San Francisco where she lived for some time with the band members of The Tubes. But after a year she returned to the East Coast where she studied at the Hartford School of Art for one and a half years. When in 1976 she moved to New York, where she did odd jobs for a living, she made new contacts with artists of her generation. Kiki Smith then worked as part of a group of artists called Collaborative Projects Inc., Colab for short, a loose gathering of young artists, among many others Tom Otterness, Cara Perlman, and Robin Winters. They intended to bring art and life together in

a more direct way with exhibitions outside the established art scene, using fax networks and similar activities. In *A. More Store* they sold artistically transformed everyday objects and artists' multiples at reasonable prices and Kiki Smith made scarves and printed T-shirts. In general, what was important to the group was their artistic motivation outside the commercial mainstream. The themes of the time and materials from everyday life became the basic elements of an art which wanted life and vitality, in contrast to an art scene that was becoming more and more paralyzed by commercialism and abstract academicism.

In the legendary *Times Square Show,* organized by Colab in an abandoned massage parlor, Kiki Smith showed her large-format, embroidered drawings, which she had created using motifs from Gray's anatomy book, for the first time. With her *Nervous Giants* (1987) she outlined the theme that would determine her art in the following years: the human body in all its forms, its concrete physicality and our ideas of it.

Not unlike the dissections of the human body carried out by Renaissance artists, not unlike Leonardo's studies which dealt with the proportions of the human body, Kiki Smith explored the significance of the body as a system. She fragmented it and made models of its different parts in order to understand them better. In a deeper sense, understanding means a process for Kiki Smith that is never just purely cognitive but means producing a physical presence in order to be able to get a notion of reality.

In this context she herself liked to talk with laconic humor of her "Frankenstein strategy," for her concept of fragmentation was

always intended to lead to an authentic perception of the whole. "Our bodies have been broken apart bit by bit and need a lot of healing; our whole society is very fragmented. ... Everything is split, and presented as dichotomies — male / female, body / mind — and those splits need mending." [4]

Kiki Smith has thus modeled the human body in a variety of ways. She created sculptures of the digestive system, the uterus, the liver, the kidney and the heart as well as of the chest and the limbs. She dealt with bodily fluids and showed both their life-saving and fatal effects. All this resulted in a comprehensive series of works which was interpreted — not accidentally — in connection with social discussions about the body, Aids, gender roles, etc. But in this context her work was read more than once too one-sidedly as a political statement — and nothing could be more unjustified. For Kiki Smith's work is not what Elias Canetti desperately termed a "torture chamber of thinking," but a "treasure chamber of seeing." [5]

Birth and death became the central subjects of the first years in which Kiki Smith dealt with the theme of the human body. She made a womb out of bronze, a closed body which can be opened like the two parts of a nutshell to show its void. In parallel and closely connected with this sculpture, Kiki Smith made numerous drawings that show babies in the protected security of their mothers' wombs.

In taking up the subject in the drawing, in choosing an artistic equivalent, in deciding how to represent it, the artist's view of the nature of things becomes clearer. This is a concept that Kiki Smith was to follow consistently and that at times created confusion.

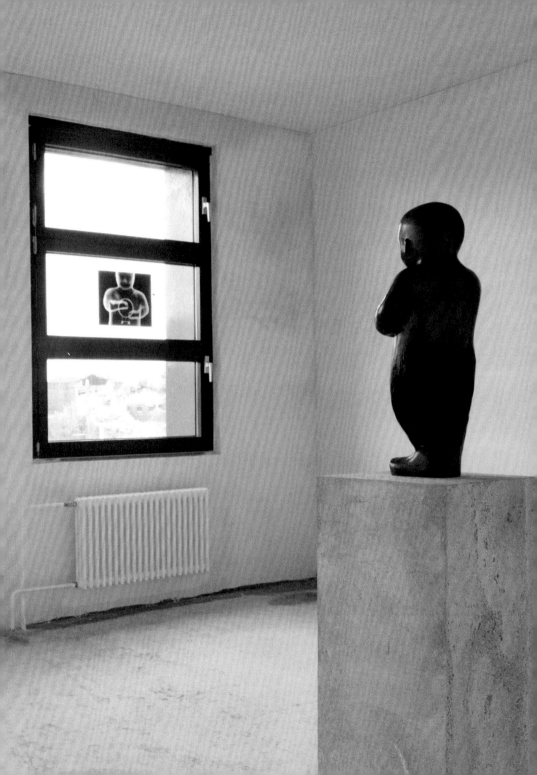

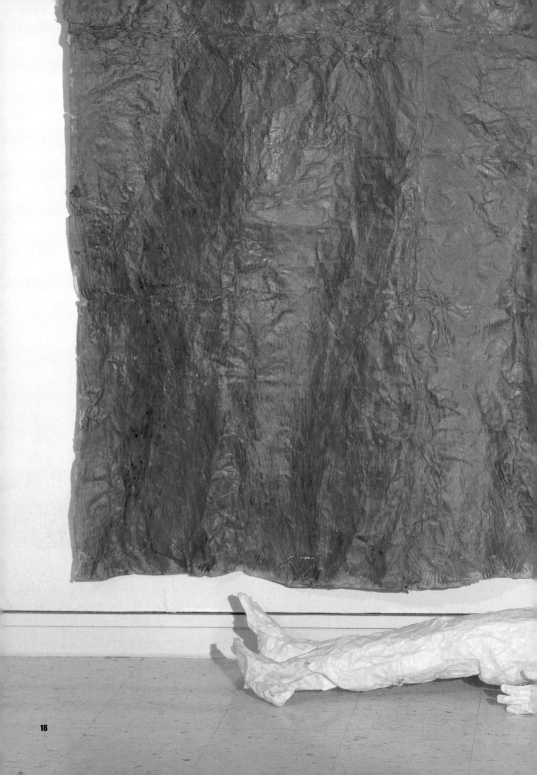

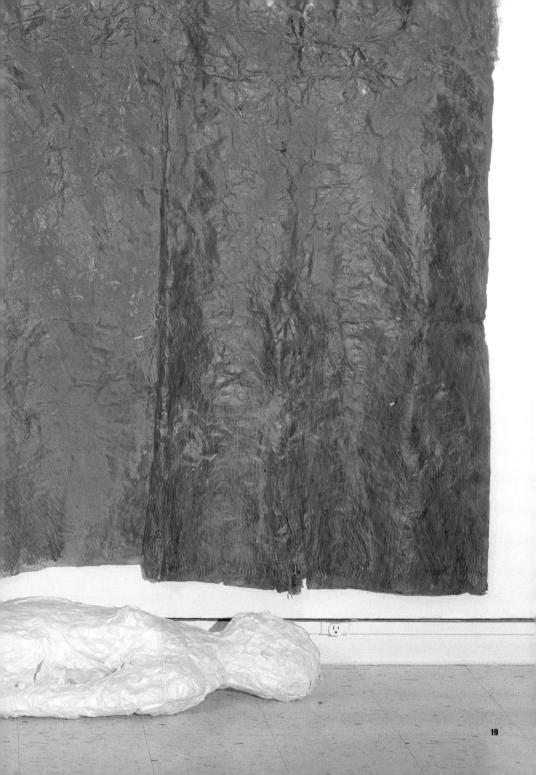

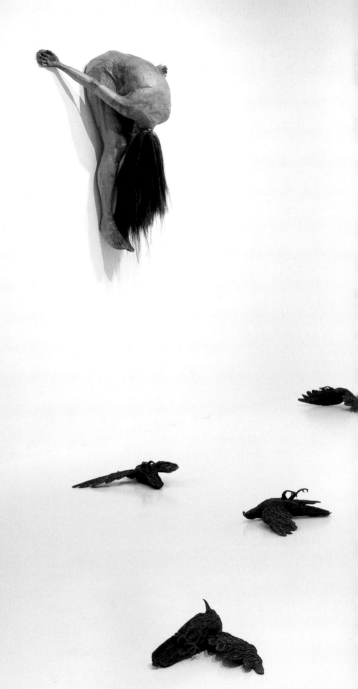

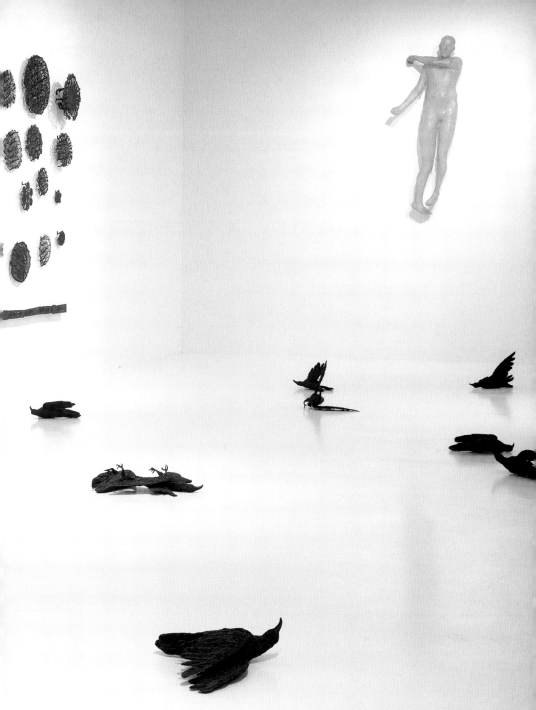

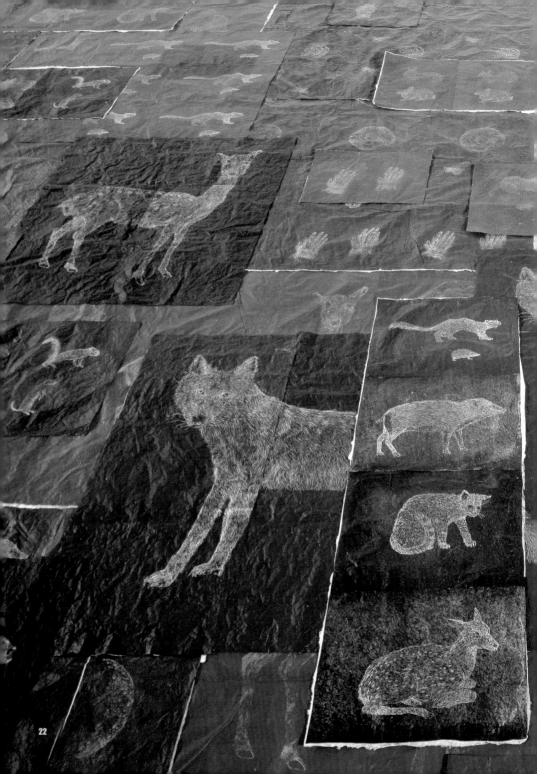

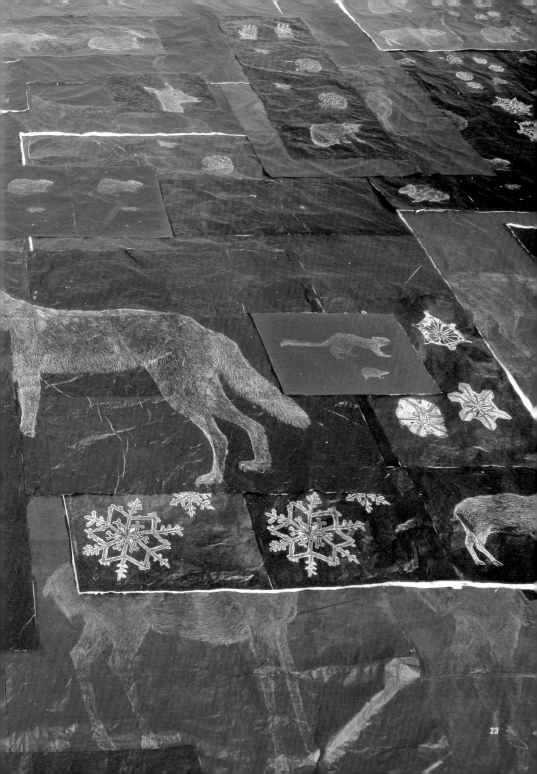

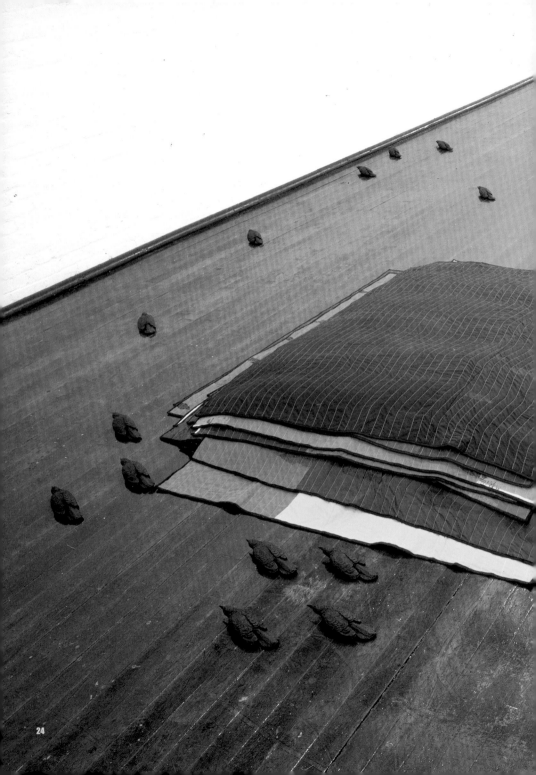

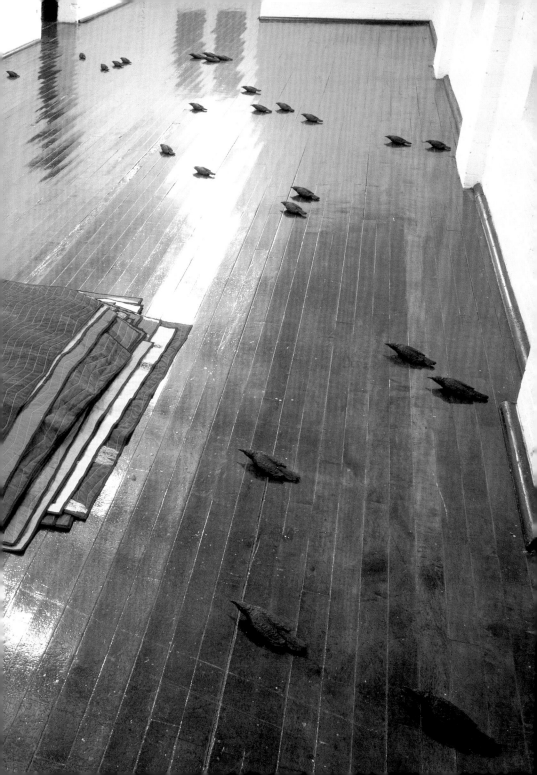

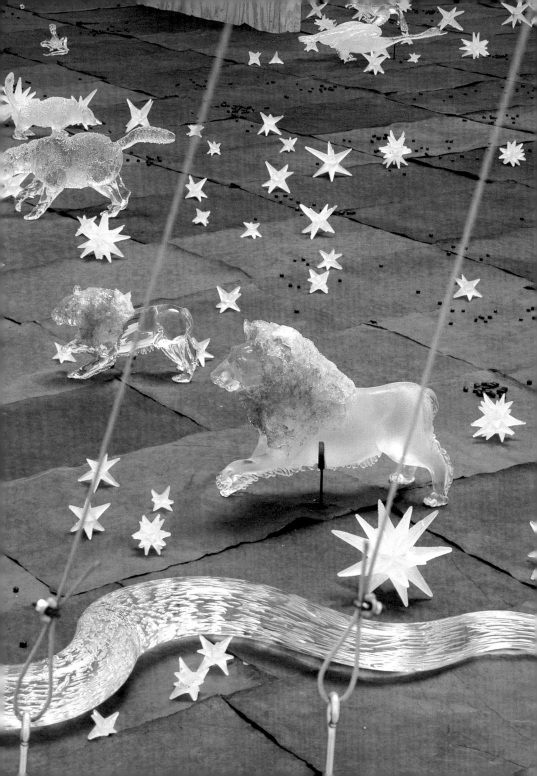

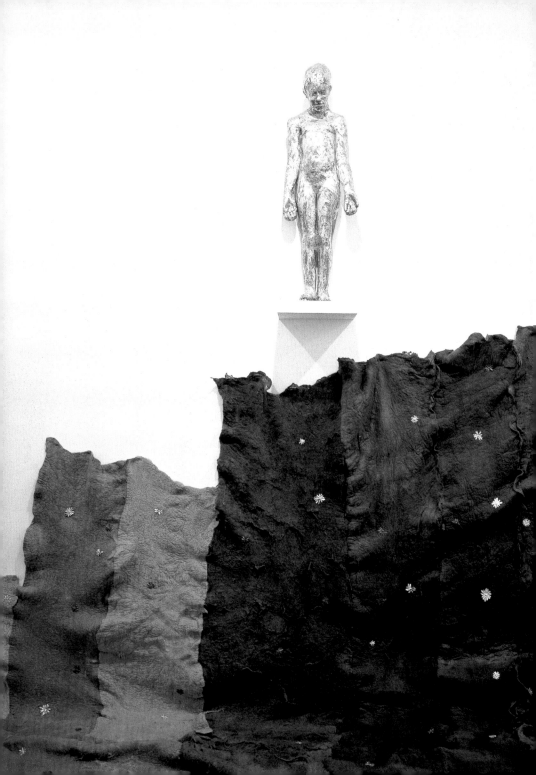

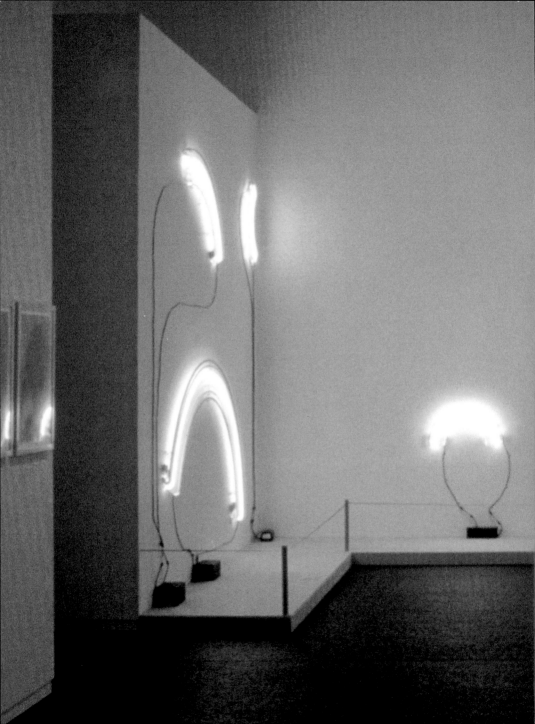

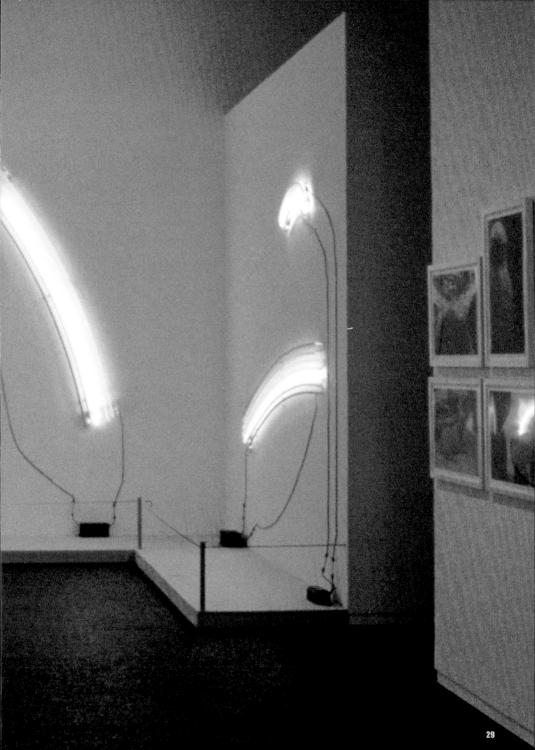

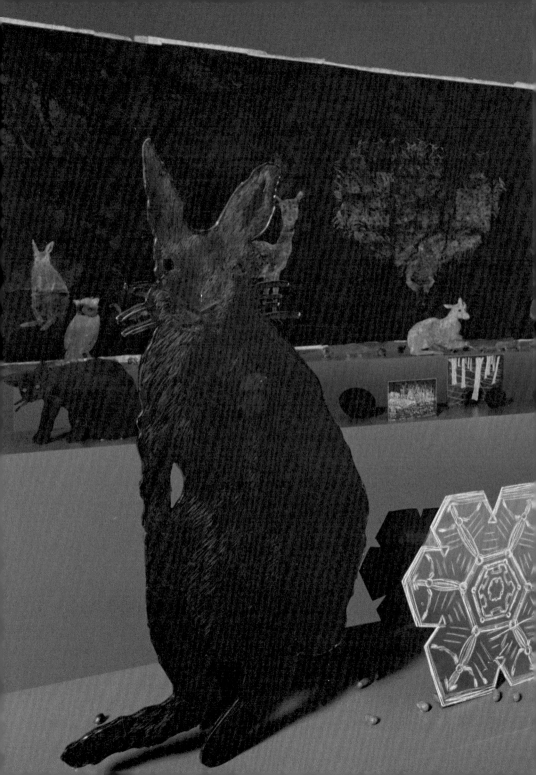

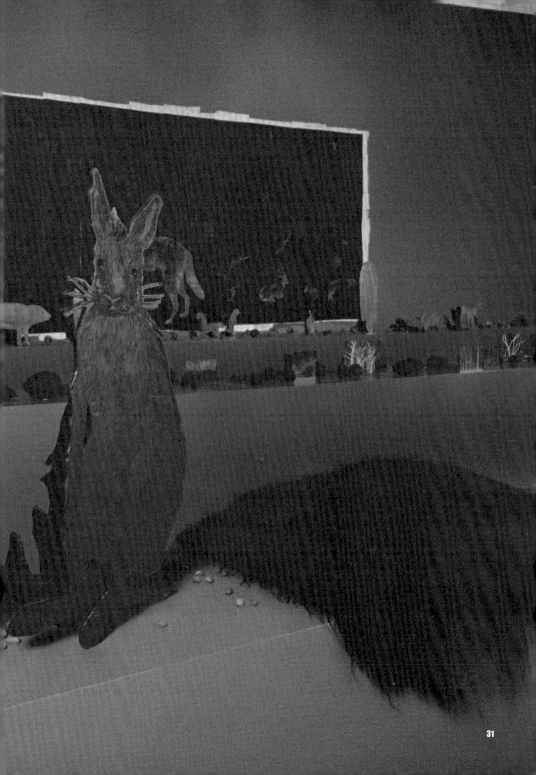

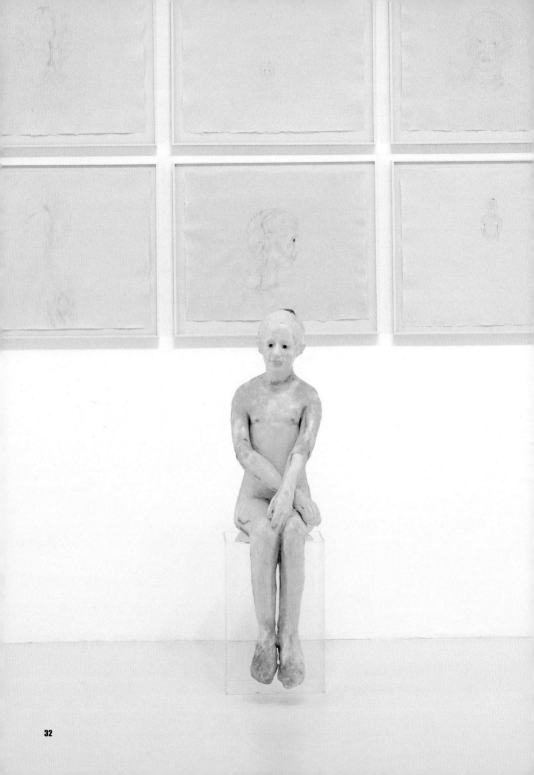

Claudia Gould, a good friend of the artist, said in an interview that she had been especially surprised by the drawings of unborn children that seemed to her like a plea against abortion, and yet she knew that Kiki Smith was in favor of women's freedom of choice and of their right of self-determination concerning their own bodies. This is one of the many examples that show that these works cannot serve as statements. No matter how shocking they may seem, and no matter that they seem to precisely express central subjects debated in society, they nevertheless remain entirely within the realm of curious contemplation, of naive openness. These works are perception and contemplation — a scrutinizing, questioning gaze. A quest for penetration into a world full of secrets.

"My work was very autobiographical. In the pieces about birth I was trying to reconcile an ambivalent relationship to being here on earth because earth is a difficult place to be sometimes. Individually the pieces are about other things, but I know they're basically about me saying I have to learn to be here. I made some stained-glass paintings with images of babies being born — half in half out — and it was like me saying, I'm sitting on the fence, I have to make some decision about being here."[6]

To give dichotomies of our existence material form in real bodies is a conceptual strategy that Kiki Smith pursues in many of her works. Life and death are represented as physical states of our existence. They are very close to each other and one may suddenly turn into the other; a little too much, a little too little of certain substances may be decisive. The Janus-faced nature of forces becomes the central motif in those works in which Kiki Smith explores

bodily fluids. She inscribed the names of them in Gothic letters on receptacles that were used in pharmacies in previous centuries, in times when there was still a relationship between form and trade. The artist presents an altar of these fluids and their aura. The fluids, which keep the human body going, appear next to each other on equal terms, irrespective of the positive and negative connotations we attribute to them in daily life. Sweat, sperm, blood, mother's milk, saliva, urine, pus, lymph and tears are considered as both life-giving and life-saving as well as fatal elements of a complex system. Among other things it becomes obvious how much views apparently based on science fade out central elements of our existence and remove them as unpleasant by-products to a far-off world of things strange and foreign. We thus need this artistic staging of an alchemistic altar in order to recognize what is part of us as a value given by creation and to accept it as our own bodily experience.

What Kiki Smith wants is the reanimation of areas of human existence already believed to be lost. At the beginning of her artistic career we find works like *Hand in Jar* (1983), which seem to be metaphorical expressions of this notion. In a preserving jar the artist keeps a hand preserved in a greenish liquid. On the surface of the hand algae grow for which the dead organism has become the source of new life. Reviving what is lost, what seems to belong to the past, what is declared dead, becomes a central motif of the work, not only with regard to central themes, but also in the revival of past techniques, materials and pictorial subjects.

The secret lines of communication between life and death appear in a number of works. In *Second Choice* (1987), Kiki Smith

forms vital organs, in particular those which play a decisive role in our metabolism and which therefore have no place in the territory of poetic language. She places these forms in a bowl, a kind of vessel for sacrificial offerings, where on the one hand they look like fruit, the fruit of life, and on the other hand like merchandise you may purchase. Once again she touches on a social subject, the trade in organs, the black market of life which affects those regions of the world where in economic terms the life of an individual is "of no value" because it can be paid for, it can be bought.

In never-ending variations Kiki Smith plays with the countless relations that exist between the experience of our body and the socially legitimized parameters of our perception. A brief moment during the installation of her show at the Kestner Gesellschaft may illustrate this. Kiki Smith asked for a yardstick that really deserves its name because it measures feet and inches and is not subject to the decimal system with its centimeters and meters. It was not a question of longing for what you are used to, for the system of measurement customary in the USA, but a question of principle: "Inches have a relationship to the body, they are derived from it, they are a human measure, while centimeters measure in a way that subjects the world, centimeters are pure capitalism." (K. S.)

Thus the way Kiki Smith perceives the world has nothing to do with scientific exactitude. The issue is not to measure the world or to obtain theoretical concepts beyond our perception but to regain a direct relationship with the world, a relationship that retains our theoretical knowledge of the world, yet is not considered to be the be-all and end-all of everything.

What is decisive is what I would like to call the romantic force of this work, the creation of a poetic world as a level of authentic perception—disconnected from the perceptual paths of information.

We mentioned above the closeness of this artistic approach to anatomical research in the Renaissance. In his notes published under the title *Die Provinz des Menschen (Province of Man)* Elias Canetti described the strategic coldness of Leonardo's artistic conceptions which appear like a counterpoint to the melody of Kiki Smith's work:

"What is most striking about [Leonardo] is his spirituality: he points the way to our downfall. In him our disparate efforts still hold together; but for all that, they are not less disparate. His belief in nature is cold and terrible; it is a belief in a new kind of rule. He can foresee its consequences for the others, but he himself fears nothing. It is precisely this fearlessness that all of us are possessed with; its product is technology. The juxtaposition of machine and organism in Leonardo is the most frightening fact in the history of ideas. At the beginning machines are no more than drawings from his hand, his game, a controlled whim. The anatomy of the human body to which he had succumbed is his principal passion and allows him his little machine games. Discovering intelligence in this or that disposition of the human body gives him the desire to think about intelligent inventions of his own. Knowledge still has this strangely fermenting character; it will not calm down and it avoids any system. Its restlessness is that of perception which does not only want to perceive what it believes; it is *fearless* perception, a fearless-

ness always prepared and a gaze always prepared. What happens in Leonardo's mind is directly opposed to the aspirations of mystic religions. They strive for the fearlessness and calm obtained through perception. But Leonardo uses his peculiar fearlessness to achieve perception, which to him is the means and end of his effort for every individual object."[7]

The gaze which Kiki Smith manifests in her works is never fearless, but marked by naive openness; it knows about the dark sides of the world and looks for images in order to integrate them into the structure of life.

In retrospect it seems consistent, yet surprising if you go back in time, that Kiki Smith created her first pair of figures in 1990, a man and a woman, a contemporary couple, an Adam and Eve of the 20th century. Exposed, suspended on a metal frame, exhibited like a species in a natural science museum, we see two members of homo sapiens. Their heads bent, their faces barely outlined, as if they were hidden under pale veils, the figures persist in a kind of terribly lifeless apathy. The surfaces of the nude bodies do not possess homogenous and academic beauty; the yellowish skin is full of reddish traces of color, of spots and stains, that form a kind of corporeal topography. The inside pushes towards the surface and indeed the red wax of which the bodies are made shines through; we see a representation that gets under our skin. Yet the inside pushes towards the outside in still another way: milk springs forth from the woman's breasts and runs down her body, while sperm flows down the man's leg. The life-giving fluids run down the lethargic bodies into a senseless nothingness; they give neither life nor desire, they

dry up empty and meaningless. In lifeless isolation a vegetating and sad existence is shown, cut off from elementary energies, detached from creatural experience and physical presence. It is a moving emblem of a time that creates its values from the functionalizing of one-dimensionally governed forces.

In line with the Frankenstein myth and parallel to her research into the organic system, Kiki Smith then increasingly formed complete human figures, thus staging the complex interaction between outer shell and internal processes.

There her interest was captured by those figures that are themselves part of a complex system, that is figures which embody religious and mythological notions of the human being. The anthropomorphic form as an image of a conception of the world became another central subject of her work. In this, too, different focal points of social discussion intersect.

Kiki Smith pursues this track, explores it and thus once again and in an even more precise way gets under the skin of things. She brings to light the wounds of the physical as cracks in our consciousness.

Her *Virgin Mary* (1992) has lost any embellishing aura, we not only see her nude but stripped of her skin, too, with visible muscles and veins like an *écorché* figure from the time of Leonardo. We see a body that is fleshy and vulnerable, naked and de-mythologised, and at the same time we see a figure that turns her open palms towards us both in powerlessness and to bless us. The attitude of imperturbable, exposed and defenseless perception and meditative contemplation recurs again later in childlike figures like that of *Blue*

Girl (1998). But these figures are created initially to show the tension between physical vulnerability and spiritual greatness.

Mary Magdalene (1994), the sinner who does penance in the desert outside society's order. Mary Magdalene, the woman without clothes whose body is protected by luxuriant hair, a wild animal-like being — Kiki Smith presents her with her head raised, she is full of hair, but the belly, the face, the breasts defy this growth of hair. She is attached to a chain—the creatural is imagined as a shackle. And the wilderness is a product of administered order against which this proud figure seems to rebel.

Lot's Wife (1996) is also presented as in the biblical story. She was turned into a pillar of salt because she did not obey the law not to look back when they were fleeing from Sodom and Gomorrah. She was asked to forget her past and not to look at what was happening but to have trust in the imposed principle. She, too, one is tempted to say, exhibits this upright pride and goes her own way. This figure seems like a metaphor of Kiki Smith's work, an image of her trust in her own gaze as the only way as well as the way out in her existence, "looking back to her people, the past, and the physical." (K. S.)

As if it were a kind of ongoing text Kiki Smith makes use of images of past periods and gives them a contemporary face. The important thing always is to liberate connoted contexts, to look with a different gaze. *Lilith* (1995), for example, Adam's first wife, refused to submit herself to a male order. She was expelled and became the womb of demons, a symbol of fateful femininity. In Kiki Smith's conception she becomes a figure that is not tangible, that

defies the law of gravity and squats against a wall — a mental body with spiritual force.

Yet Kiki Smith was not only interested in figures with Christian connotations; in her work we find cosmological configurations from all cultures. *Nuit* (1992) is an Egyptian goddess who gives out the light of the sun in the morning and swallows it in the evening. The figure of light that was often shown in Egyptian iconography with arms that embrace the whole world, is presented as a cosmological system with arms and legs.

In *Untitled (Upside-Down Body)* (1993) Kiki Smith plays with a figure from a Celtic myth. Shela Na Gig ridiculed dominant manners and morals by lustfully exposing her vagina in public. Kiki Smith's bronze figure seems dug out from the quarries of the past — there is still slag on her body. Only the part of the body that Shela Na Gig extends ostentatiously to the world is laid bare in its glassy smoothness. As the object of a desiring gaze it is in fact added to the figure as a separate and exposed part.

The zone of the broken taboo is adorned with a net of pearls. The luminous web is like a halo of nocturnal stars and throws an aura of seductive magic onto the surrounding space.

These figures have a new and mysterious appearance in the poetic and magical realm that Kiki Smith created for her exhibition at the Kestner Gesellschaft. Surrounded by the creatures of her art — the stars, worms and mice, the butterflies, bird and peacocks, the rats, cats and wolves, the ice crystals and moon — the whole forms an apparently enchanted world of fable that speaks of the nightmares of our time in a very tender and discreet way.

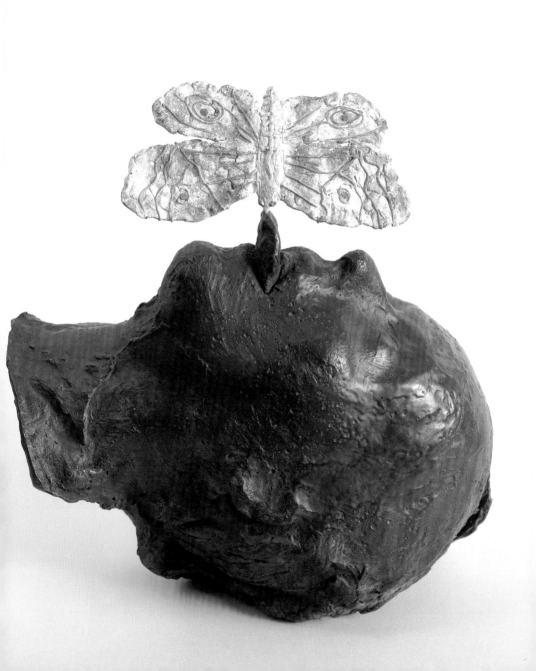

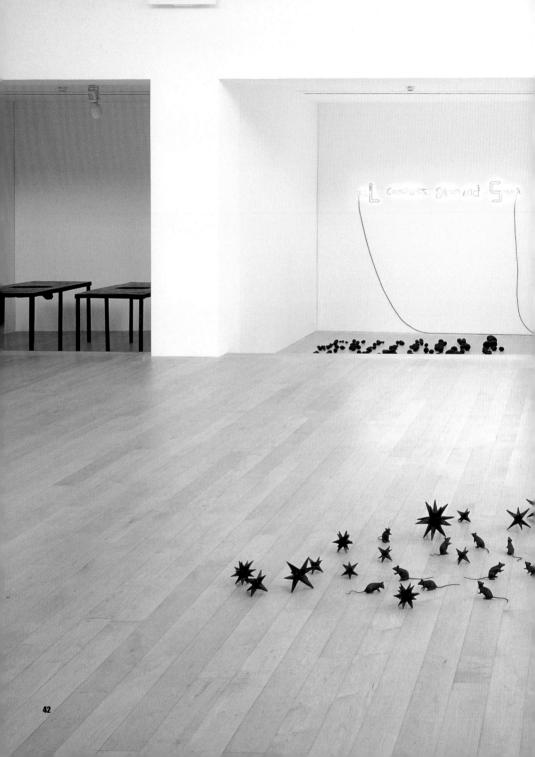

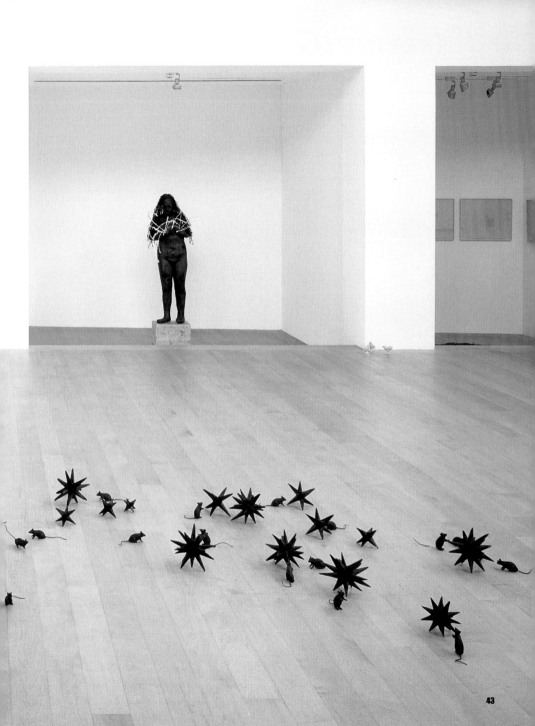

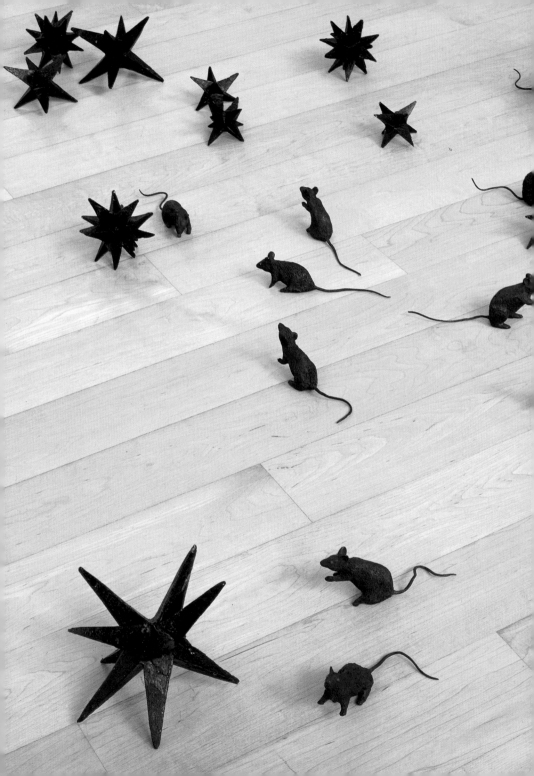

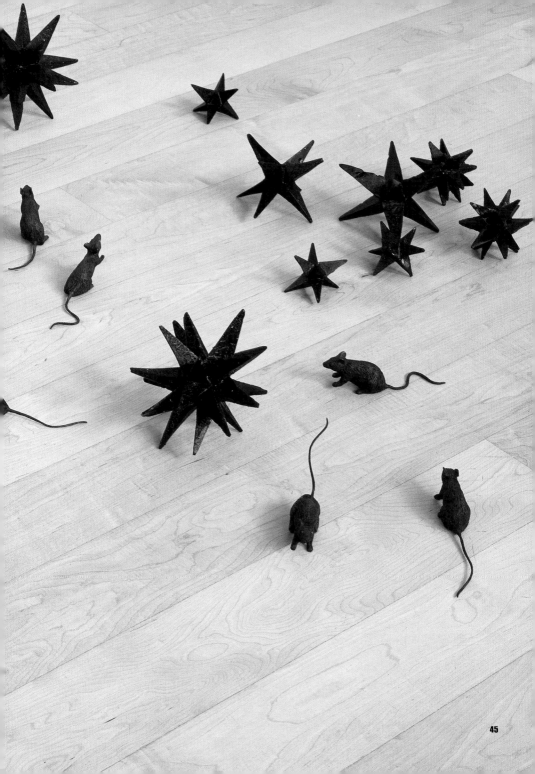

eat and Small

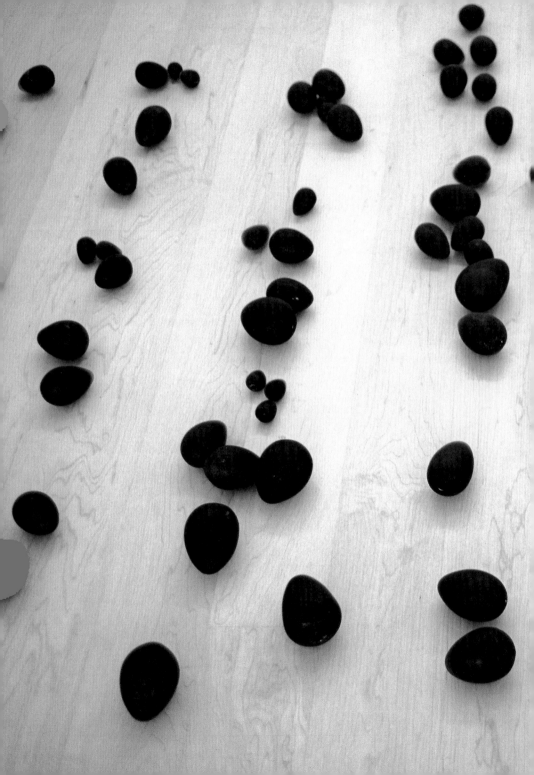

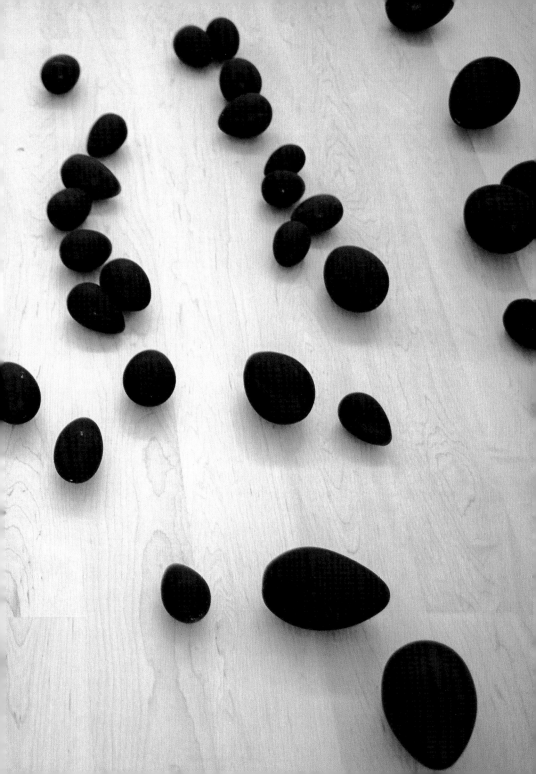

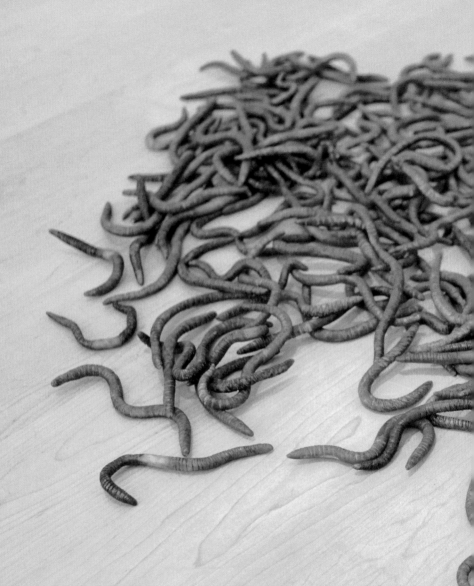

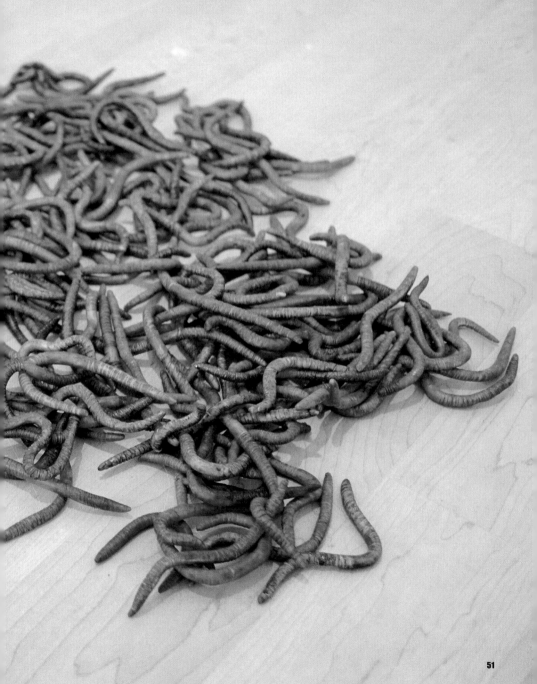

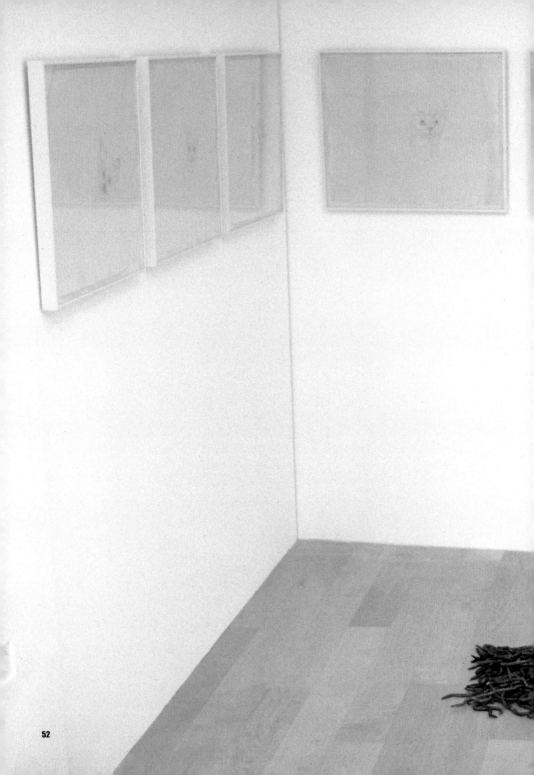

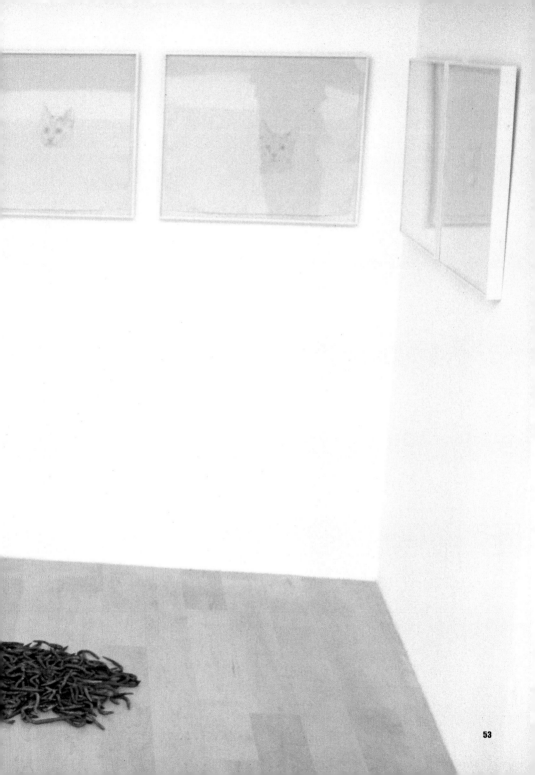

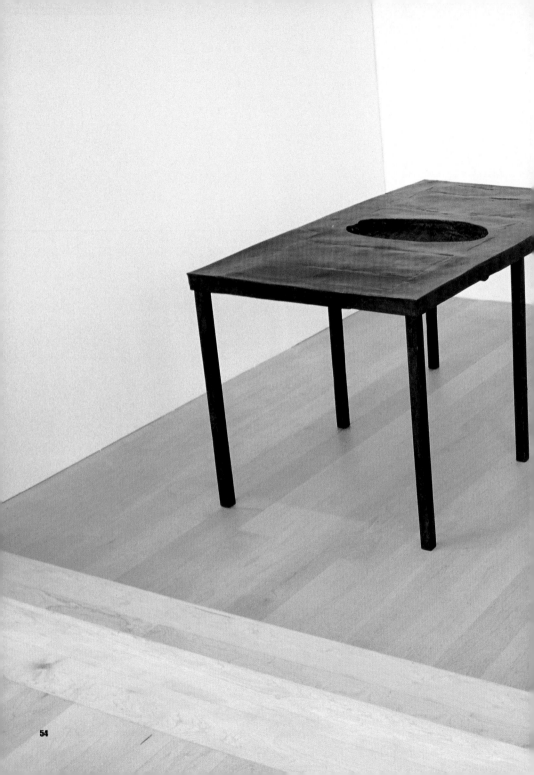

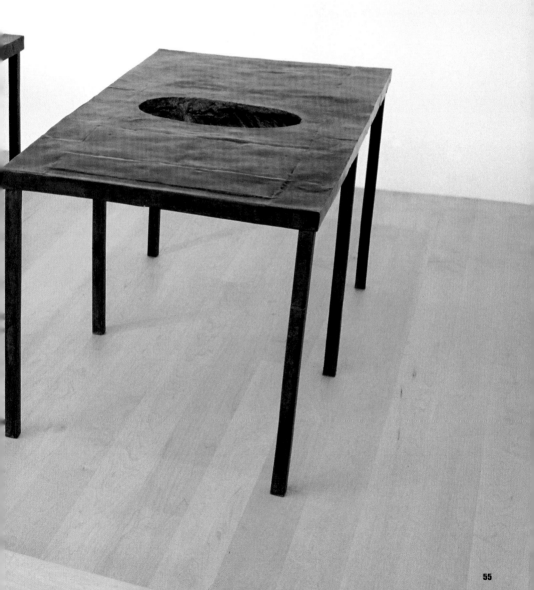

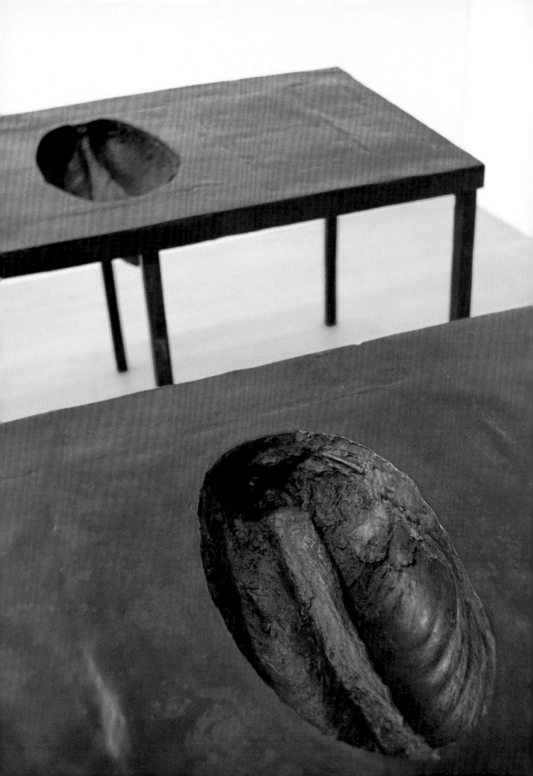

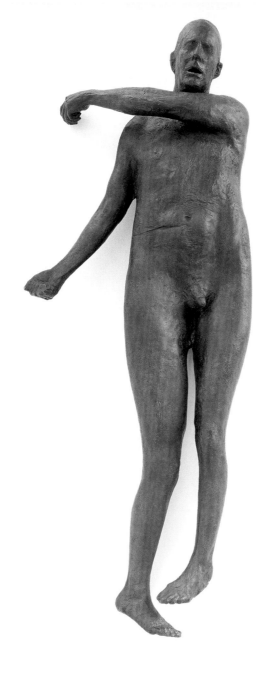

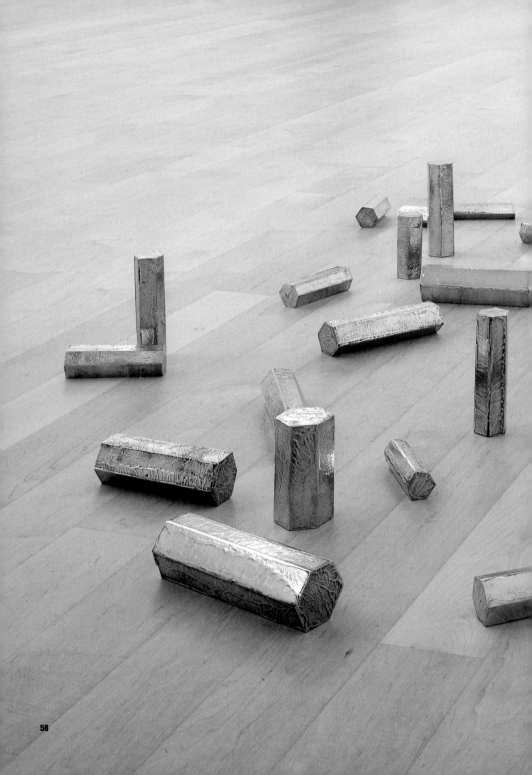

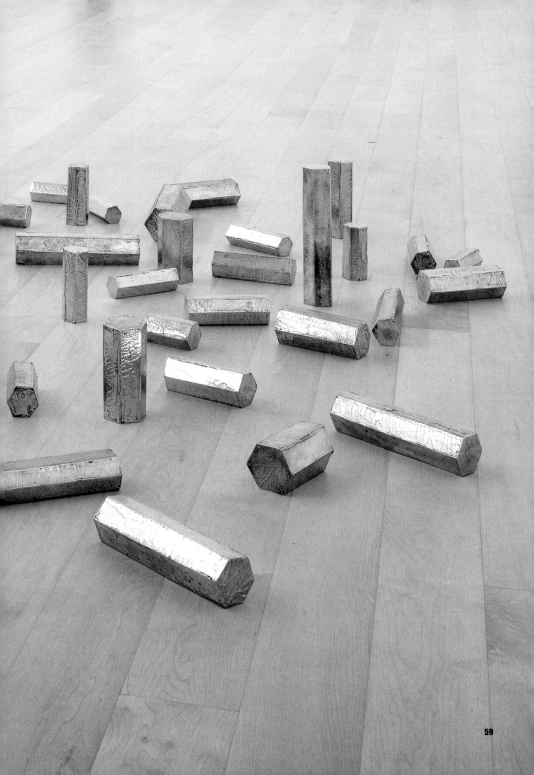

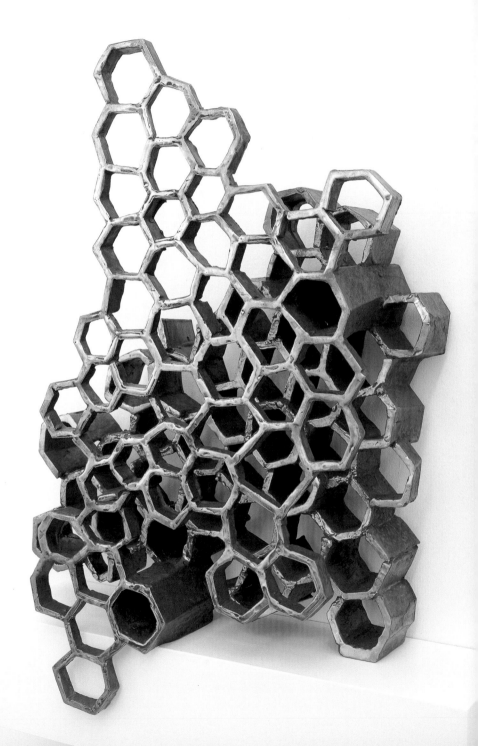

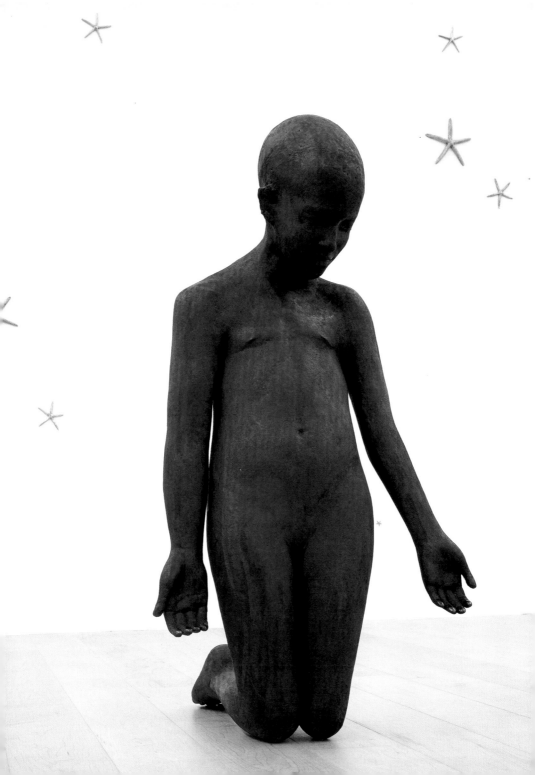

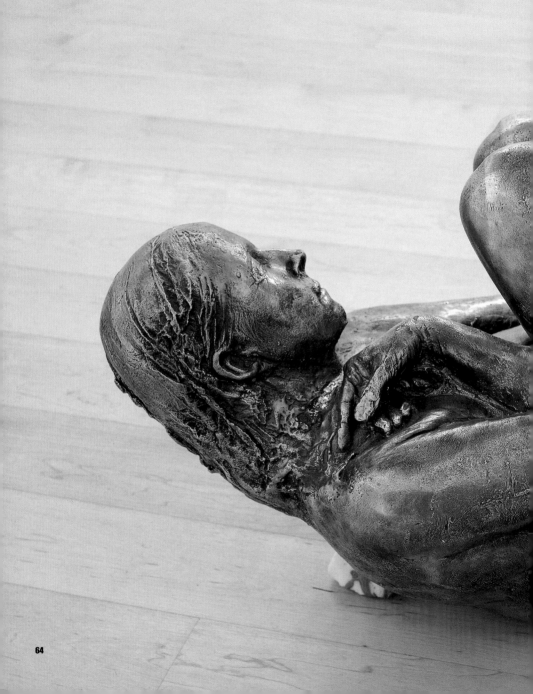

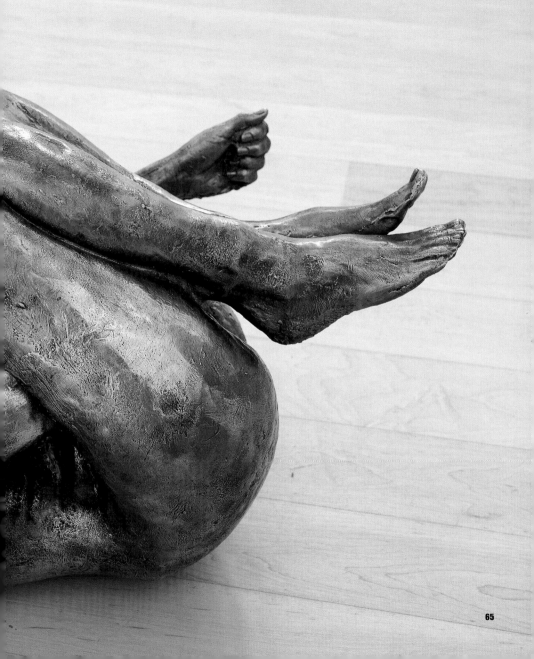

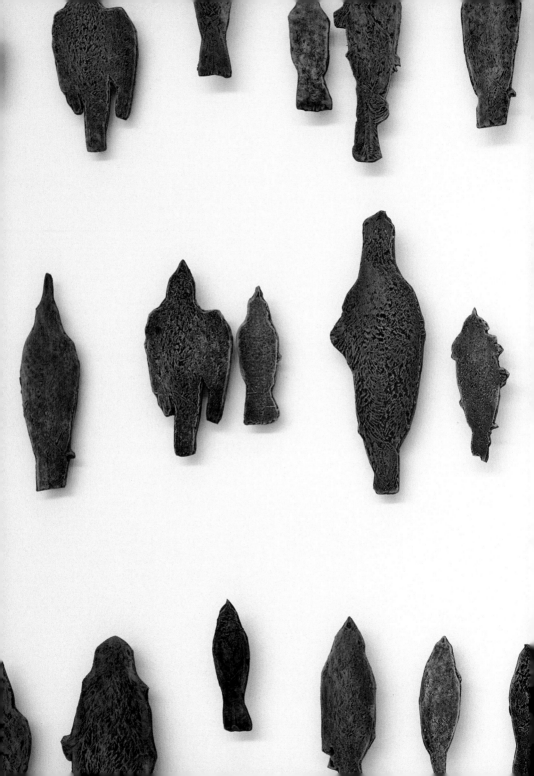

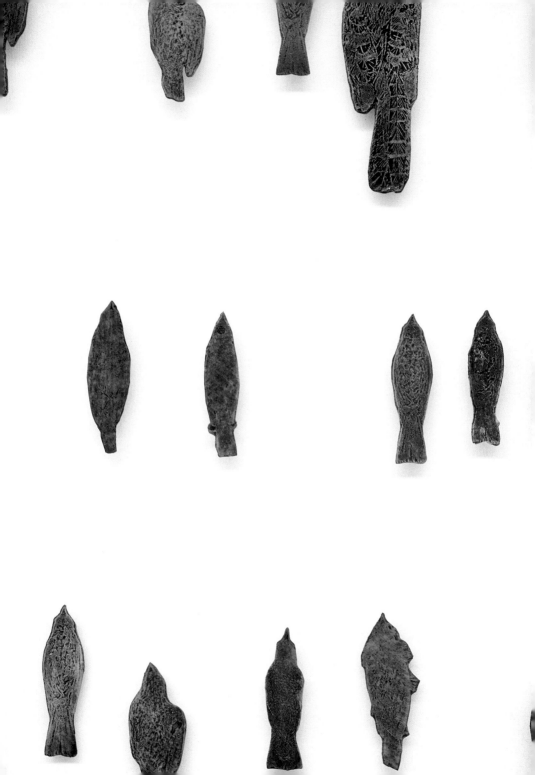

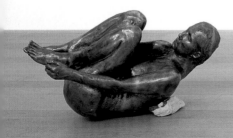

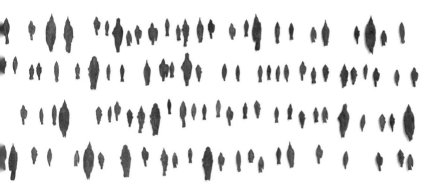

THE BIRDS W

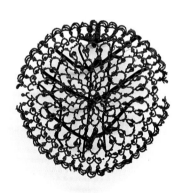

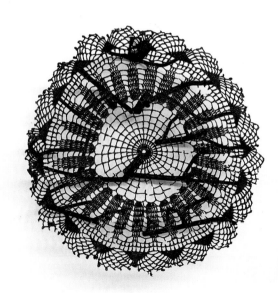

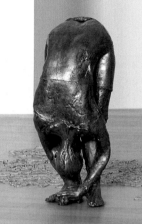

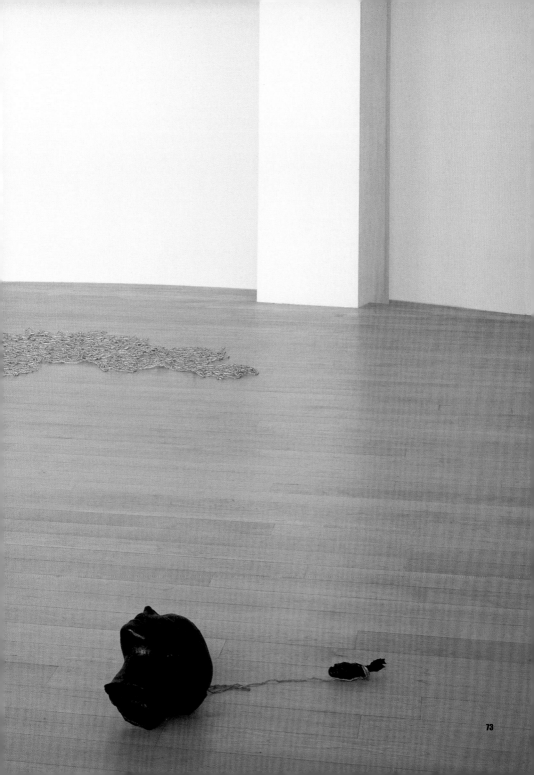

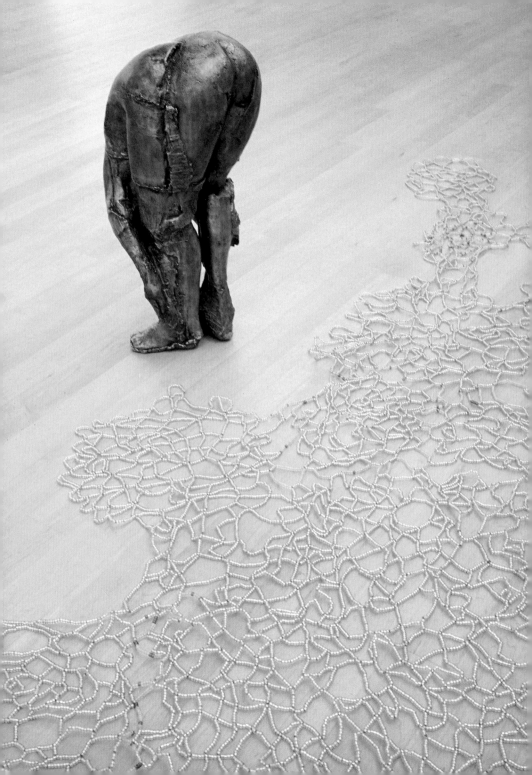

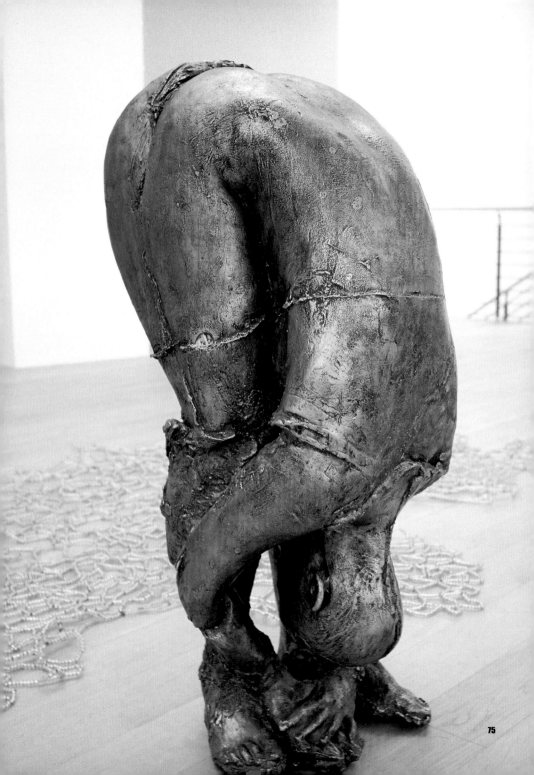

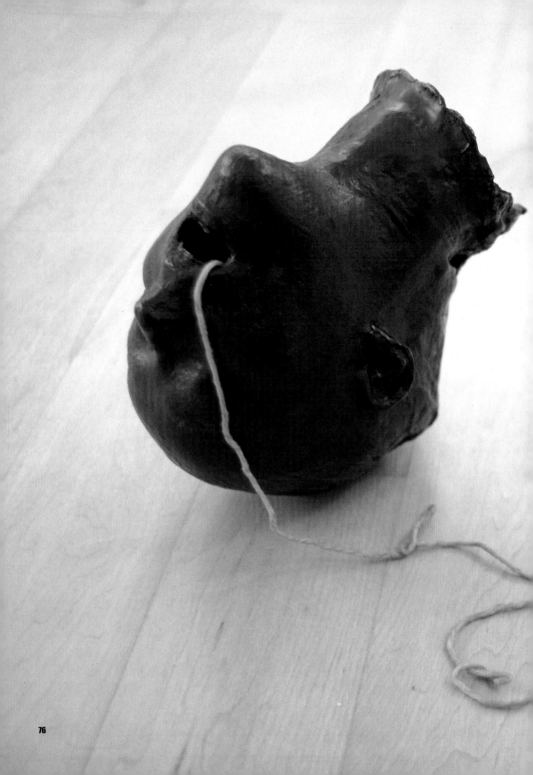

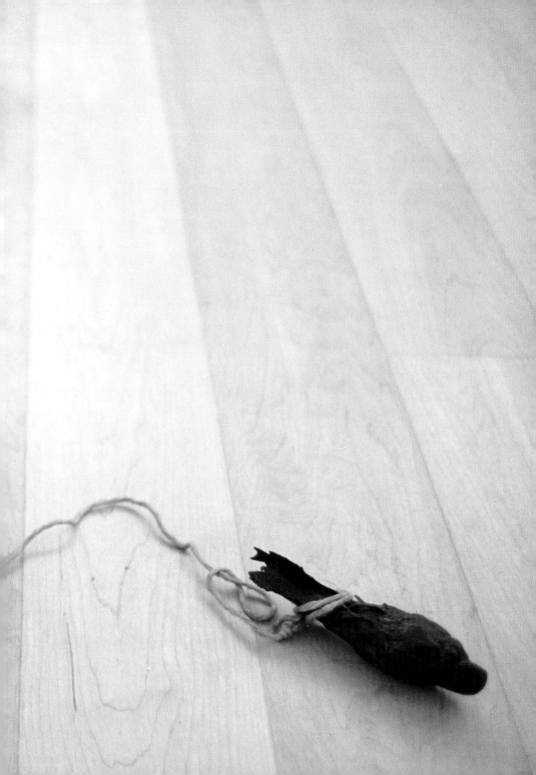

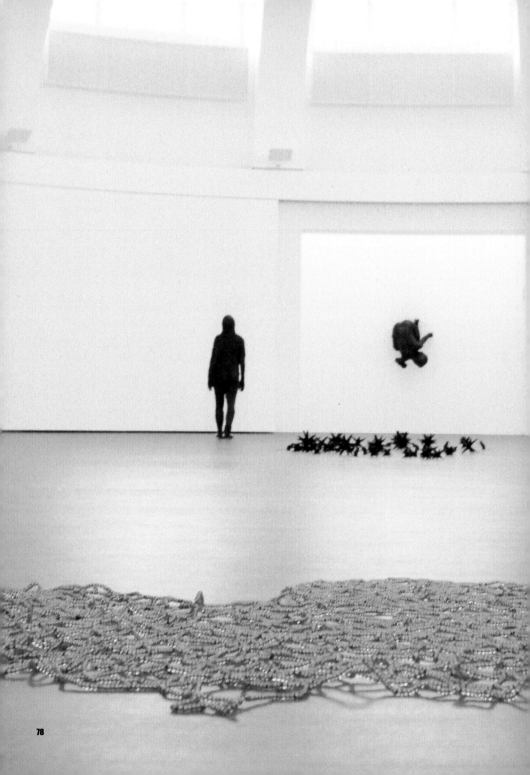

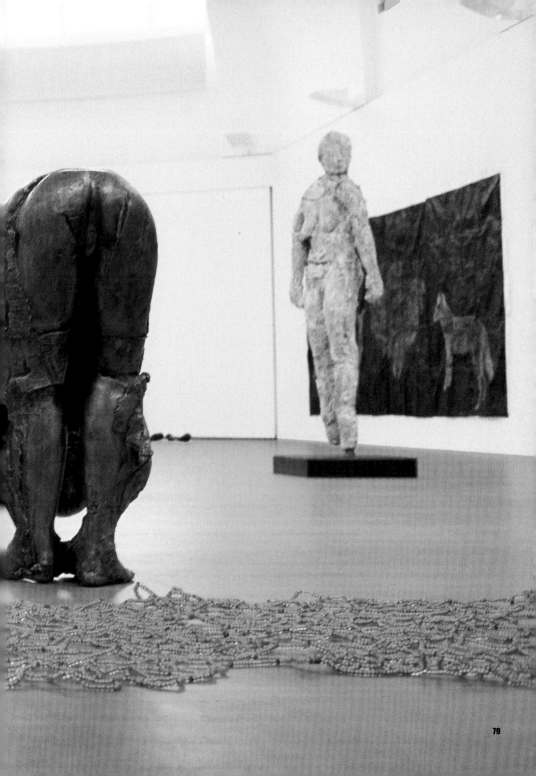

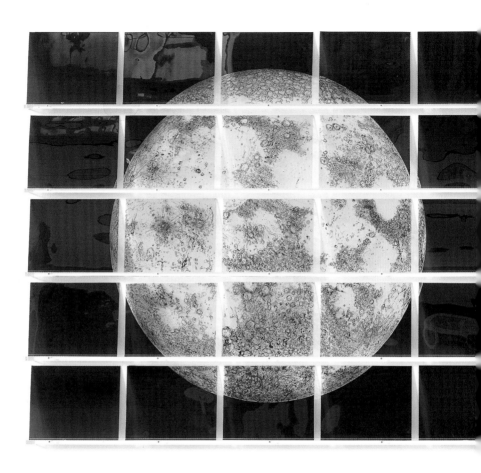

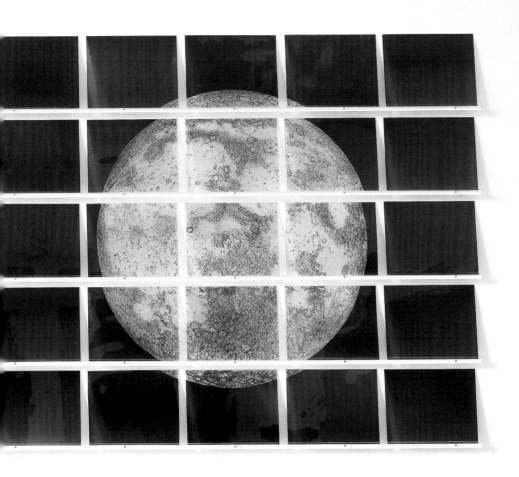

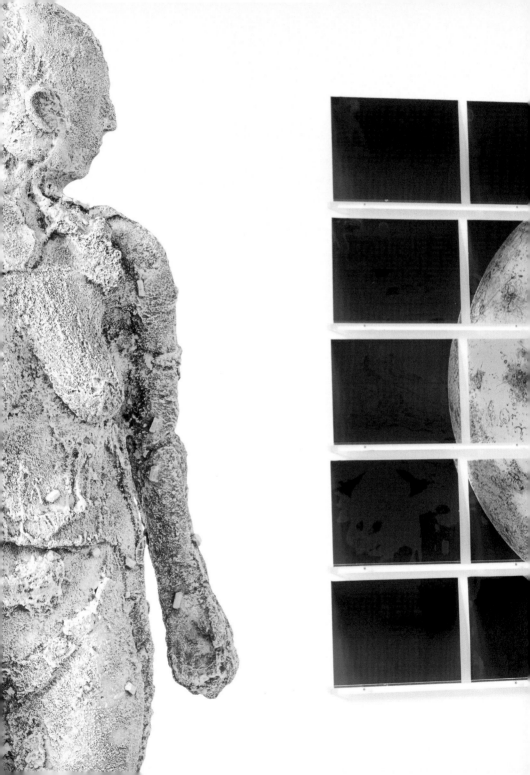

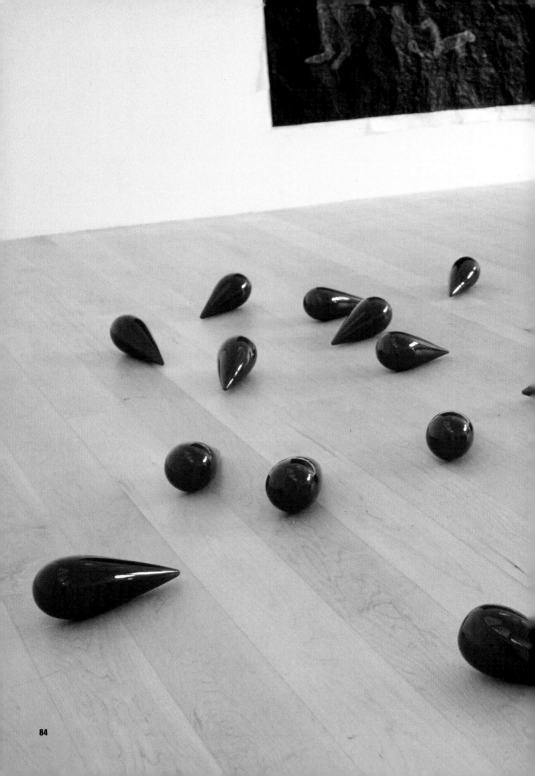

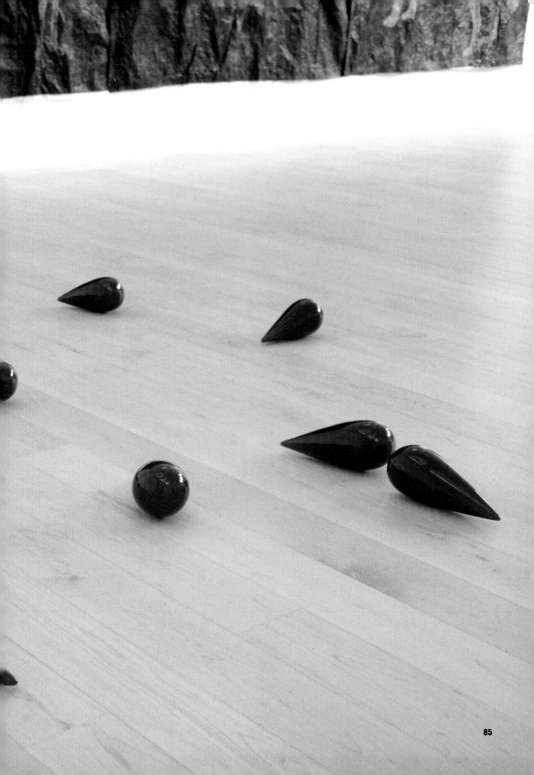

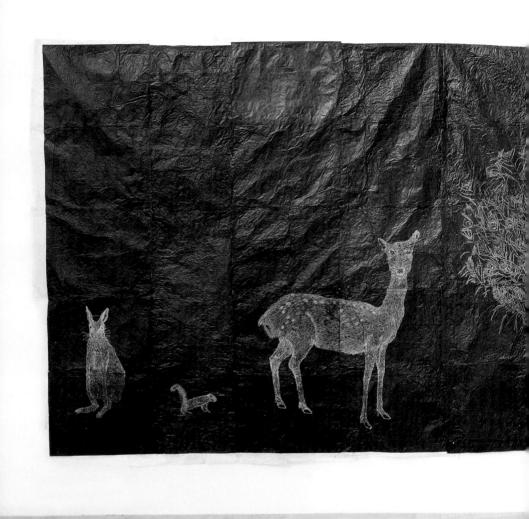

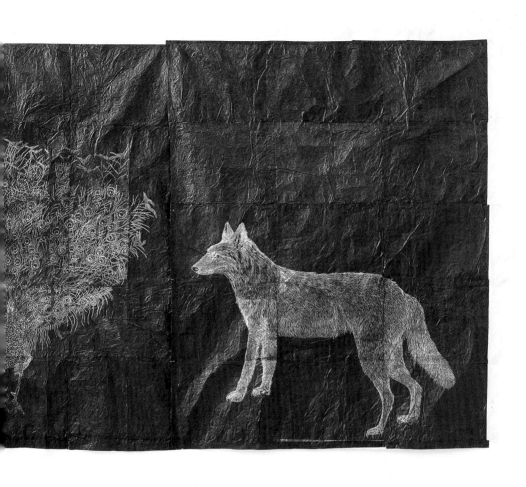

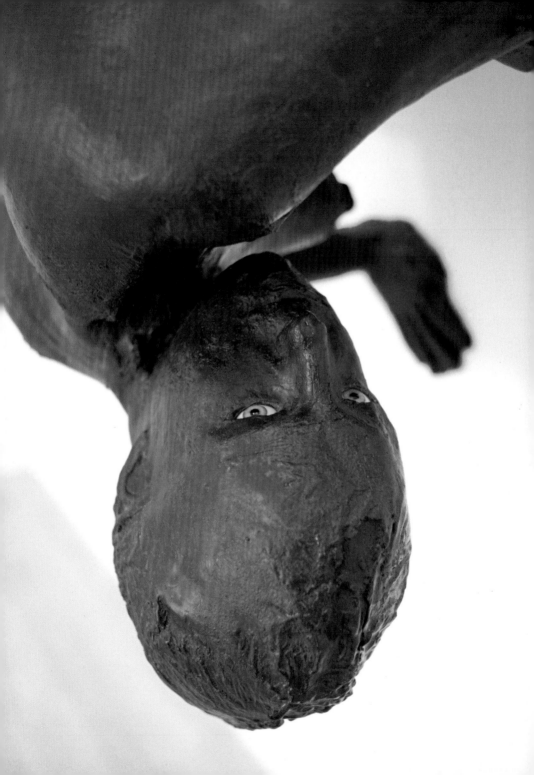

"All Creatures Great and Small"—God made them all / God loves them all—and for some years now Kiki Smith has included them in her artistic worlds.

At the beginning of this new chapter of her work there was a dream. One night Kiki Smith dreamt of a scene where she was asked to "get the bird out." This mysterious birth, as she presents *Getting the Bird Out* (1992), opened up a new field for her work—man's environment, the world of animals, natural landscapes, the stars and planets, in short the entire cosmos.

Since then Kiki Smith has created visions of the continents, crystalline forms of natural phenomena like ice or snow, the stars and the moon in a variety of artistic forms; but in particular she has created animals and has been drawing and modeling her Noah's Ark, which is both a huge lifeboat and a veritable ship of the dead.

Since Kiki Smith expanded her work to include the animals and the natural phenomena, her artistic language has at first glance become more tender. But this is deceptive. Instead of operating with the images of shock she now operates with the shock of beauty. She exposes our schizophrenic and broken relationship with nature which we sentimentally admire, yet destroy in reality, in her poetic world, like a child.

Her exhibition at the Kestner Gesellschaft is beautiful like a fairytale—and in a certain sense it is also conceived like a fairytale. Grace and horror, fear and hope are interwoven in a mysterious way. A poetic space has been created that tells us what the things we are surrounded by mean to us and, in particular to Kiki Smith, and what ideas we associate with them.

Kiki Smith assembles the elements of her art, old and new works generate constellations never seen before. Figurative and abstract forms come together. And their coming together brings forth mysterious, dreamlike narratives.

In one of the recesses of the Kestner Gesellschaft's large hall the title of the exhibition shines in bright green neon. In this hall Kiki Smith has called together the very different creatures of her art. In front of the neon piece, in its green light, pitch black eggs lie in various forms and sizes — they resemble a minefield and thus mark a birthplace of mourning. Life and death characterize this space. To its left we see the *Cadaver Tables,* altars of bronze, with the impression of a body visible in their tabletops. To the right there is a female figure that appears in the blue of heavenly spheres; her breasts feed the stars or comets, silver shimmering constellations which may hold our fate in the balance.

The hall is dominated by the mythological figures — but in its center the weird encounter of an army of mice is even more dominant; they appear like guards in a forest of black stars. Once again it becomes clear that for Kiki Smith real perception is important, the truth of the gaze; the apparently disproportionate sizes of mice and stars, which are almost the same size, exactly reflect their proportions as we perceive them; the stars are no bigger than those we see blinking in the night sky. The mysterious wood is a fairytale wood of darkness where the red eyes of the mice gleam like will-o'-the-wisps. Black is actually the dominant color of the hall. As beautiful as the works may appear, illuminated by two yellow moons made of burnt glass, the masks of death are hidden in them.

Magically and silvery shining animal skulls made of bronze with golden teeth tell us the tale of the finiteness of human existence just as the series of prints *White Mammals* (1998) does, where Kiki Smith drew dead animal cadavers. And lying in front of the large-format drawing, which has a peacock enthroned in its center and is part of a series of works, a Noah's Ark cycle, are droplike objects of red glass — bloody tears in the realm of fable.

In hall IV, on the upper floor of the Kestner Gesellschaft, Kiki Smith has staged her world theatre exactly like a poetic dream. The figure of a girl appears in dark blue, her meditative head bowed, with the palms of her hands open to us in a gesture of blessing and peace. This figure from another time bows in front of a starry sky made completely of starfish. The imagination of the stars mirrors the expanse of the sea. We are in another world, in Kiki Smith's world.

Flock (1998) can be seen in the same hall. As a flat relief it shows a flock of birds, an army of shadows that Kiki Smith arranged on the exhibition wall according to plans of old slave ships. The endless repetition of similar forms deceives our gaze; we divine a mysterious movement of this flock of birds which seem to melt into a gigantic beat of wings, into a formation flight towards death. In front of this picture of collective destruction there is this figure of a woman, cast in bronze, frightened and cowering like a child in her mother's womb. The escape route away from the sufferings of existence leads back into the maternal womb; this is an image evoked over and again by the dramatist Heiner Müller in the lucid texts of his works.

On the opposite wall we read sentences from a dream (dreamt by a friend's daughter). The nocturnal fantasy speaks of tumbling birds and gouged out eyes. This nightmare about the world is accompanied by an image of clearness and coldness. Silvery shimmering bars of bronze in the form of ice crystals mark an area of cool precision. Kiki Smith is playing on her fondness for abstract form and at the same time she is stating in a sophisticated way that abstraction is also a question of the power of your microscope. High up on top of the wall we see the *Ice Man* (1995), a figure both menacing and desperate that Kiki Smith created after the discovery of a prehistoric man in the Alps. The figure's open mouth seems to form a cry — a cry from epochs long forgotten.

One idea pervades all these works like a leitmotif: reanimation. On very different levels in her work the artist strives for the reanimation of what is dead, supposedly dead. She revives old techniques and old forms which seem to be obsolete and integrates them into the contemporary contexts of her art. She questions the way our ideas develop. She is interested in old conceptions of the world, in particular if they are embodied in human idols and imagined in an anthropomorphic manner. In this context the animals, too, acquire multiple layers of significance — if we think of zodiac signs, of the worship of godlike animals and of the many images, attributes and qualities our language attaches to animals.

Kiki Smith reanimates these layers of significance on the track of another, deeper kind of experience of life, that is the daily experience of our life.

The video piece where Kiki Smith works with photographs that Eadwaerd Muybridge took of birds and horses appears like a metaphor of her artistic approach. "Photography has ruined the image," Elias Canetti says.[8] Kiki Smith reanimates in her computer the motion of the animals that was frozen in the photograph. Things that are broken must be fixed again, believes Kiki Smith, but the cracks must remain tangible. And thus we see the bird and the horse in new mysterious motion, but we notice that something is not right—we feel the story of a process between the shattering of something and its being joined back together.

Kiki Smith joins things together that we do not think belong together any more. She reanimates worlds that die too quickly within us. It is no accident that she dedicated this exhibition to her friends' children.

The Utopian vanishing point of this comprehensive artistic enterprise is that "miracle of art" on which Georg Simmel reflects in his text *Zur Philosphie des Schauspielers* (*On the Philosophy of the Actor*): "What is greatest and most mysterious in any art is the fact that it unites as a matter of course values which are separated in life in an indifferent, strange or hostile manner . . . thus giving us an idea and a pledge that at last the elements of life do not exist next to each other in such a hopelessly indifferent and unrelated way as life itself wants to make us believe."[9]

In the artistic worlds of her exhibition Kiki Smith brings worlds which are strange to each other once again into a relationship that reigns in our myths, fairytales and fables. Yet the formal

severity of her works guarantees that her oeuvre maintains the balance between the sentimentality with which we regard natural phenomena and the reality with which we repress the natural world around us, but also within us by the way we live.

Thus her work is not afraid of forms which at first appear to us to be kitsch or handicraft — they, in particular, mirror nothing else but our view of the miracles of life and the secrets of the world that has become obscured by wounds and lacerations. Kiki Smith's work switches between different modes; it is tuned both to the lyrical tone of narrative poetry and to the crystalline sound of cool abstraction and dramatic severity. You cannot find a common denominator for this work, which proceeds in concentric circles and goes over the tracks and traces on which Kiki Smith encounters the world around her.

"Just now I realize," writes Italo Calvino in his book *Kybernetik der Gespenster* (*Cybernetics of Ghosts*), "that my conclusion contradicts all the serious theories concerning the relationship between myth and fairytale. Although until today it has always been said that the fairytale, the profane narrative, is something that succeeds the myth as a corrupted, vulgarized or secularized form of it, or it has been said that fairytale and myth exist side by side as different functions of the same culture, the logic of my statements leads to the conclusion — at least until someone contradicts it with a new and convincing argument—that the existence of the fairytale precedes mythopoeia: the value of myth can ultimately only be found by continuing to play persistently with narrative functions." [10]

Kiki Smith develops this game into ever new forms before our eyes which far too quickly forget to see like a child. Perhaps "being amazed" is the word which best describes the center of this work. Kiki Smith has not forgotten to keep the curious, amazed gaze of her childhood when she was reading a fairytale. Or as she said in one of our conversations "It's about getting up in the morning and saying YES."

Translation from the German:
Michael Stoeber and Dermot McElholm

Notes:

[1] Helaine Posner: *Kiki Smith,* Bulfinch / Little, Brown and Company, Boston, New York, Toronto, London, 1998, p. 13

[2] ibid., p. 22

[3] ibid., p. 12

[4] ibid., p. 13

[5] Elias Canetti: *Die Provinz des Menschen. Aufzeichnungen 1942–1972,* Hanser, Munich, 1973, p. 93

[6] Quoted from the interview with Kiki Smith by David Frankel in: Posner, *op. cit.*, p. 35

[7] Canetti, *op. cit.,* p. 93

[8] ibid., p. 153

[9] Georg Simmel: "Zur Philosophie des Schauspielers," in: Simmel: *Das individuelle Gesetz,* Frankfurt / Main, 1987, p. 90

[10] Italo Calvino: *Kybernetik und Gespenster,* trans. Susanna Schoop, Hanser, Munich, 1984, p. 24

IRIS PRINTS 1997/98

The illustrations on the following pages show
a series of iris prints made between 1997 and 1998.
Apart from *Jersey Crows,* 1998 (foldout),
which was produced as an edition of 40, all of the other,
untitled iris prints were produced as editions of 20.
The series appeared at Pace Prints in New York.

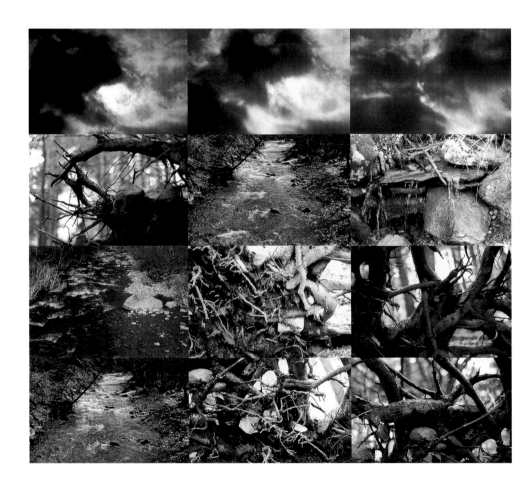

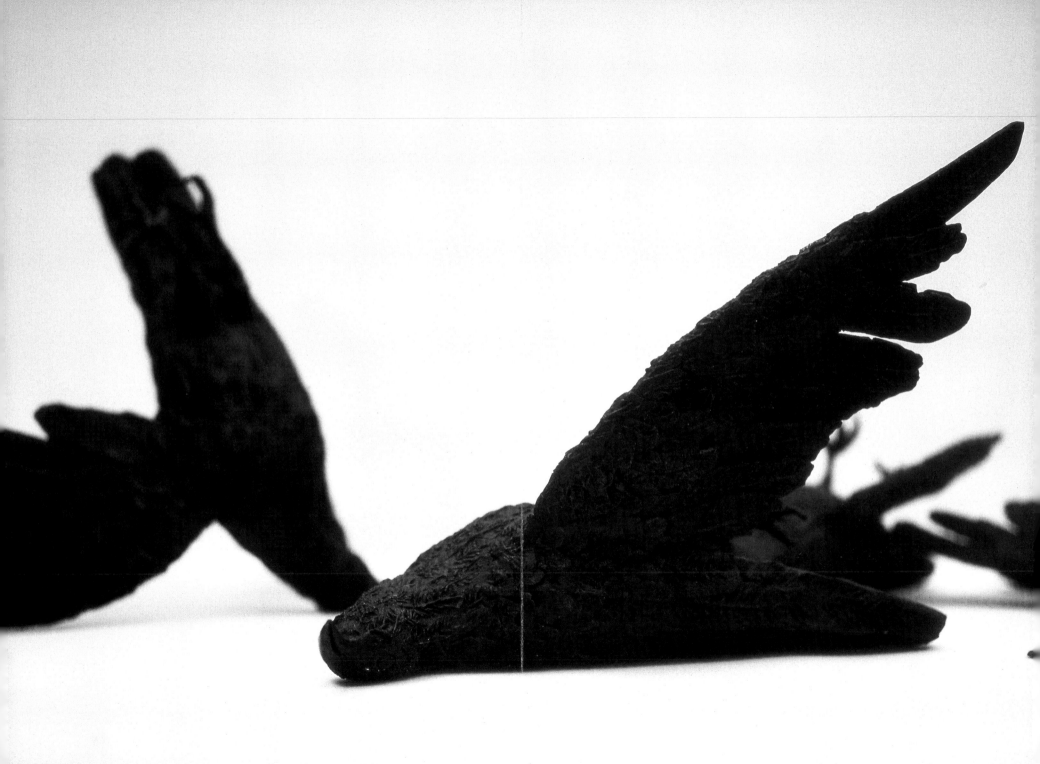

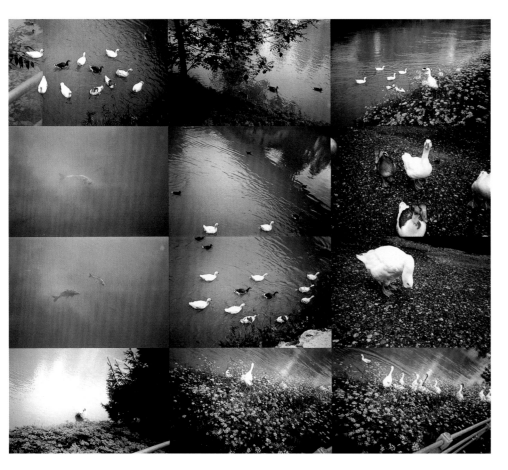

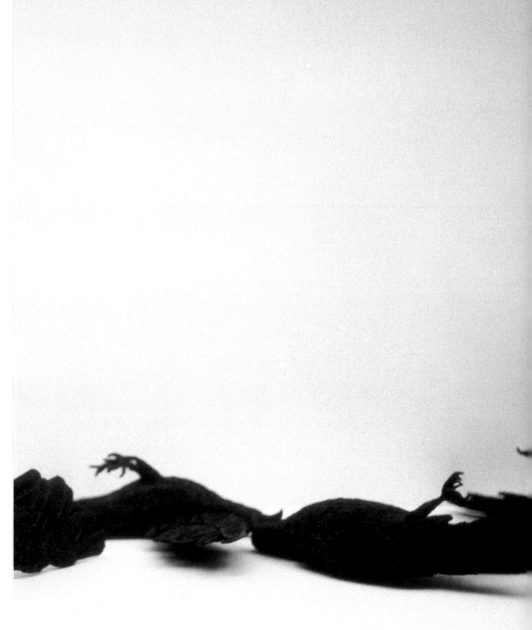

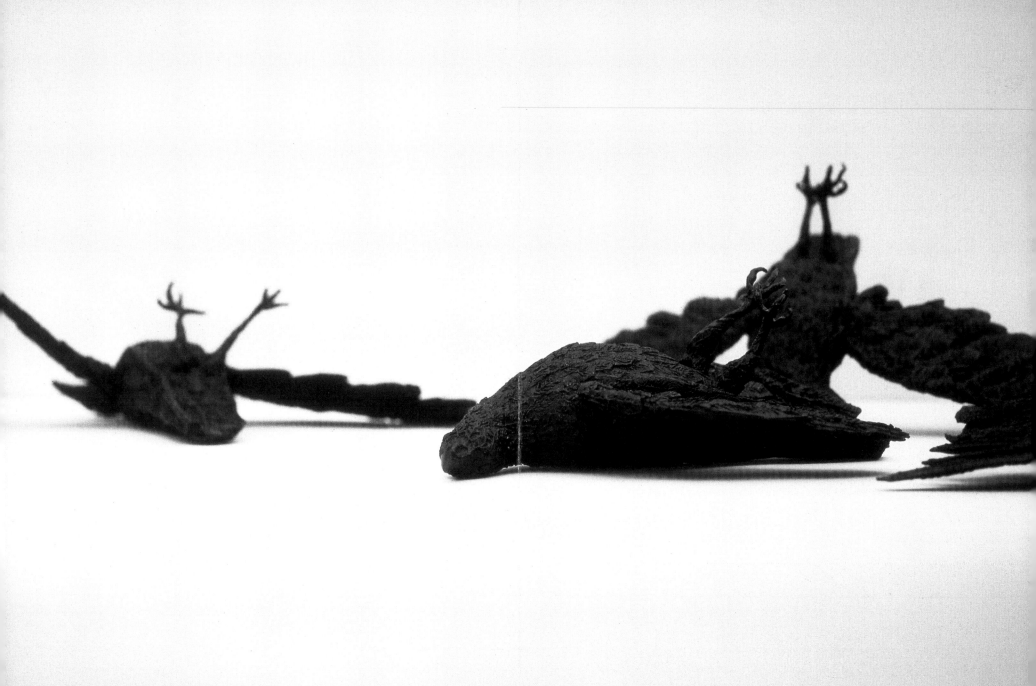

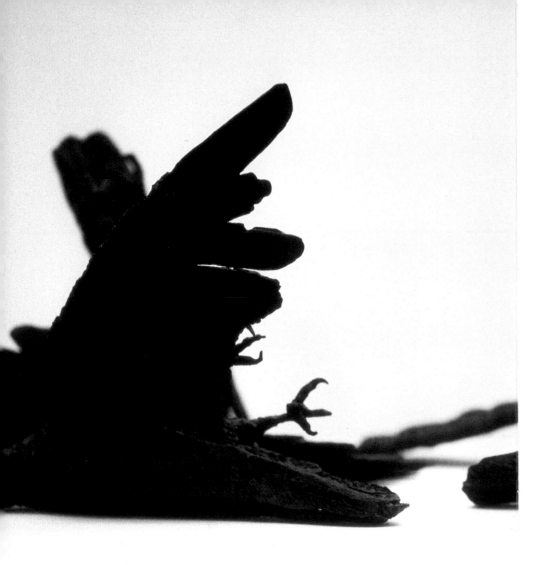

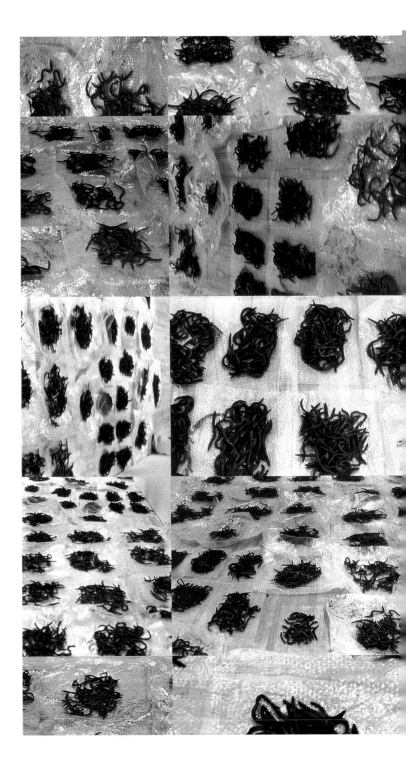

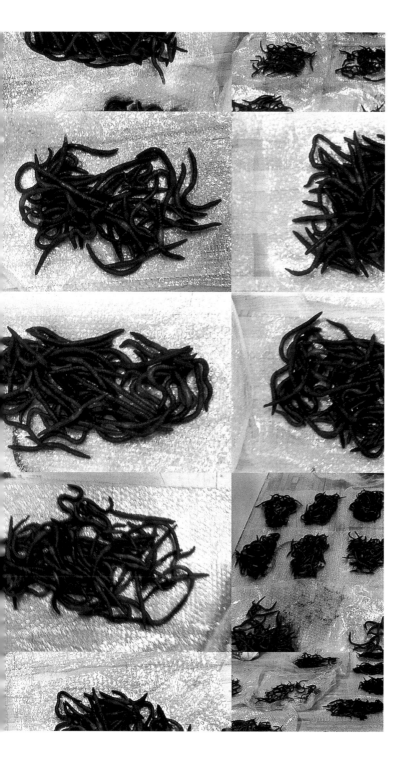

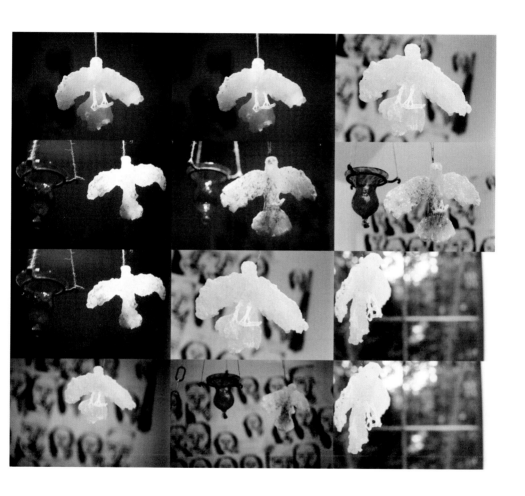

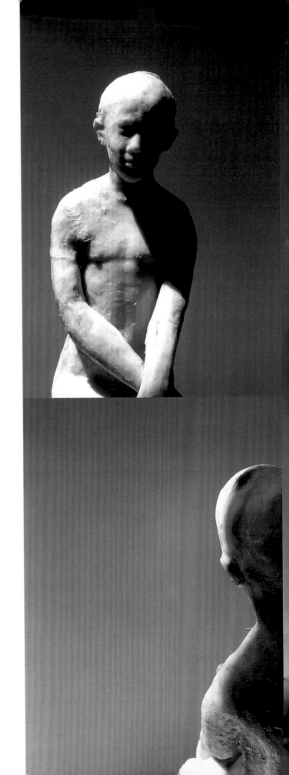

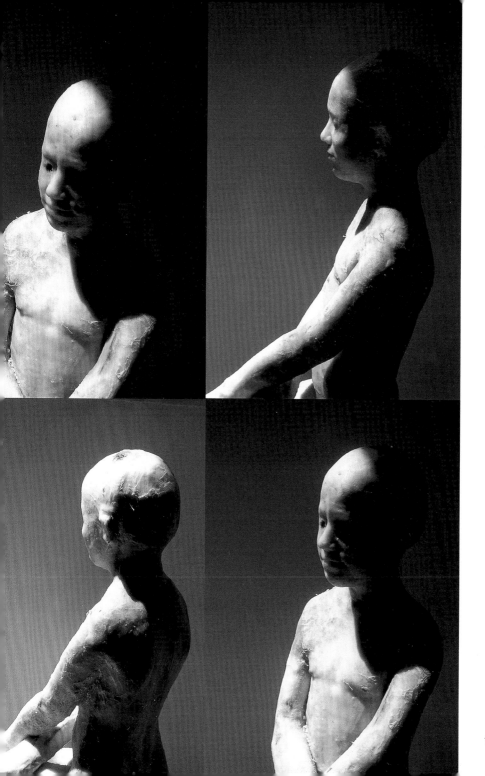

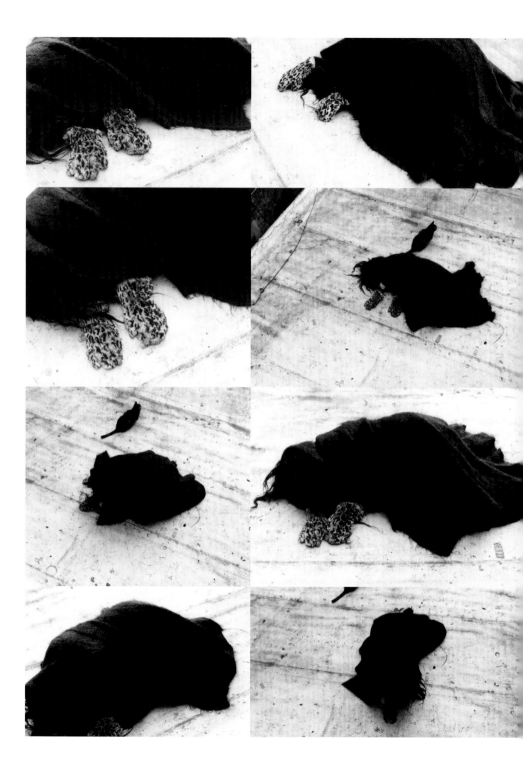

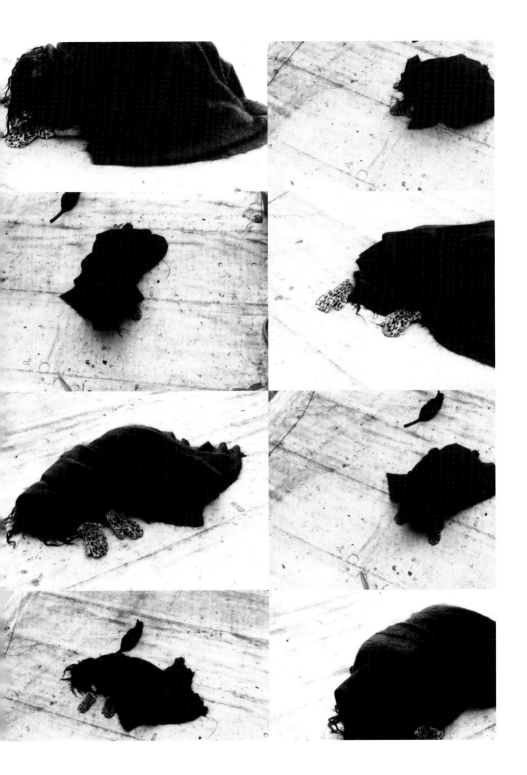

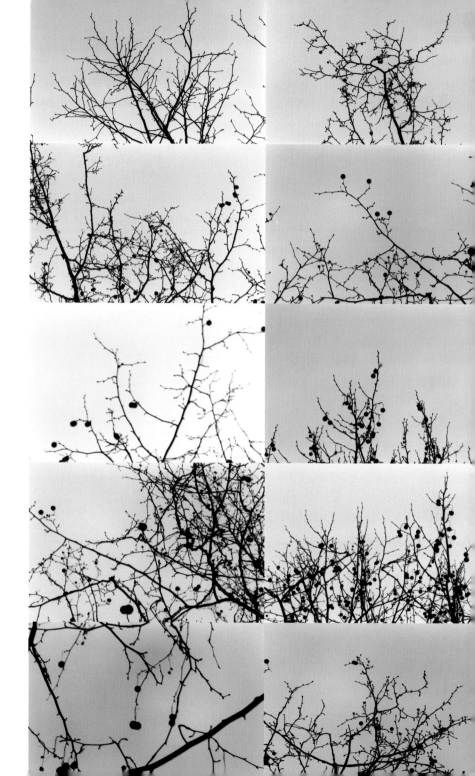

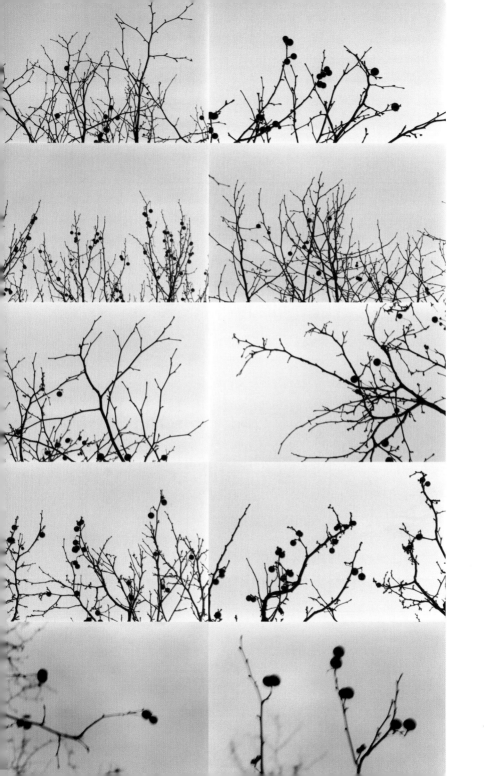

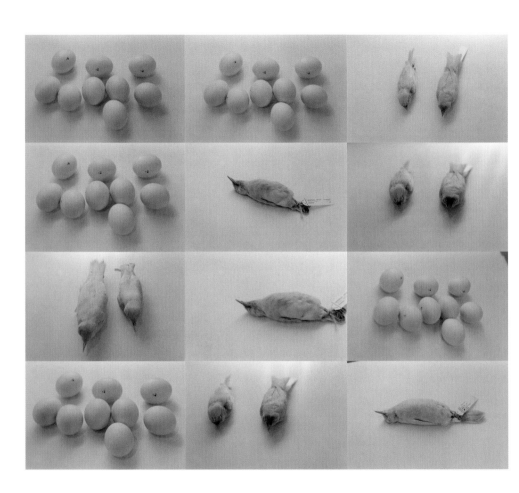

LIST OF ILLUSTRATIONS

LIST OF WORKS EXHIBITED

1

Getting the Bird Out, 1992
Bronze and string
Head: 10 x 11 1/2 x 7"
Bird: 1 1/2 x 6 x 1 1/2"
Installation dimensions variable
Jane Smith, New York

2

Untitled (Moth), 1993
Bronze
12 1/3 x 7 7/8 x 12"
Courtesy Anthony d'Offay Gallery, London

3

Untitled III (Upside-Down Body with Beads),
1993
White bronze, glass beads, and string
Figure: 37 x 14 1/4 x 19"
Beads: 148 x 75"
Installation dimensions variable
Courtesy PaceWildenstein, New York

4

Milky Way, 1993
Paper, wire, silver leaf, white gold leaf, methyl
cellulose
73 1/2 x 17 x 38 1/2"
Sammlung Goetz, Munich

5

Mary Magdalene, 1994
Bronze and forged steel
60 x 20 1/2 x 21 1/2"
Edition: AP 1/1
Collection of the artist,
Courtesy PaceWildenstein, New York

6

Lilith, 1993
Bronze and glass
33 x 27 1/2 x 19"
Edition: AP 1/1
Collection of the artist,
Courtesy PaceWildenstein, New York

7

Curled Up Figure II, 1995
Bronze
20 x 34 x 18"
Collection of the artist,
Courtesy PaceWildenstein, New York

8

Ice Man, 1995
Bronze
80 x 29 1/4 x 12"
Edition: AP 1/1
Collection of the artist,
Courtesy PaceWildenstein, New York

9

Animal Skulls, 1995
Bronze, white gold, and steel
Installation dimensions variable
Courtesy Anthony d'Offay Gallery, London

10

Red Spill, 1996
Glass
Each element approximately 1 1/8 x 2 1/4 x 3 to
2 x 7 x 7 1/2"
Installation dimensions variable
Collection of the artist,
Courtesy PaceWildenstein, New York

KIKI SMITH

1954
Born in Nuremberg, Germany. Lives and works
in New York.

SOLO EXHIBITIONS

1982
Life Wants to Live, The Kitchen, New York

1988
Fawbush Gallery, New York

1989
Kiki Smith, Galerie René Blouin, Montreal
Kiki Smith, Ezra and Cecile Zilkha Gallery,
 Center for the Arts, Wesleyan University,
 Middletown, Connecticut
Concentrations 20: Kiki Smith, Dallas Museum
 of Art, Dallas

1990
Fawbush Gallery, New York
The Periphery — Part 4, The Institute for Art and
 Urban Resources, Inc. at The Clocktower,
 New York
Kiki Smith, Tyler Gallery, Tyler School of Art,
 Temple University, Philadelphia

1990–91
Projects 24: Kiki Smith, The Museum of Modern
 Art, New York
Kiki Smith, Centre d'Art Contemporain, Geneva;
 travels to Institute of Contemporary Art,
 Amsterdam

1991
Kiki Smith: Matrix/Berkeley 142, University Art
 Museum, University of California, Berkeley
Tears Come, Shoshana Wayne Gallery,
 Santa Monica, California

1992
Fawbush Gallery, New York
Kiki Smith: Silent Work, MAK — Österreichisches
 Museum für angewandte Kunst, Vienna
Kiki Smith, Moderna Museet, Stockholm
Kiki Smith, Bonner Kunstverein, Bonn, Germany
Kiki Smith: Sculpture and Works on Paper,
 Greg Kucera Gallery, Seattle

1992–93
Kiki Smith, Galerie Fricke, Düsseldorf, Germany
Kiki Smith: Unfolding the Body, Rose Art Museum,
 Brandeis University, Waltham, Massachusetts;
 travels to Phoenix Art Museum, Phoenix
Kiki Smith, Williams College Museum of Art,
 Williamstown, Massachusetts; travels to
 Wexner Center for the Arts, The Ohio State
 University, Columbus
Kiki Smith, Shoshana Wayne Gallery,
 Santa Monica, California

1993
Fawbush Gallery, New York
Kiki Smith, Anthony d'Offay Gallery, London

1994
Kiki Smith: Sojourn in Santa Barbara, University
 Art Museum, University of California,
 Santa Barbara
Kiki Smith, Louisiana Museum of Modern Art,
 Humlebaek, Denmark; travels to
 Künstnernes Hus, Oslo
Kiki Smith, Galerie René Blouin, Montreal
Kiki Smith, The Israel Museum, Jerusalem
Kiki Smith, Galerie Barbara Gross, Munich
Kiki Smith, Laura Carpenter Fine Art, Santa Fe,
 New Mexico
Drawings, PaceWildenstein, New York

1994–95
Kiki Smith, The Power Plant, Toronto

1994–96

Prints and Multiples 1985–1993, Barbara Krakow
Gallery, Boston; travels to New Orleans
Contemporary Art Center, New Orleans;
Olin Arts Center, Bates College Museum of
Art, Lewiston, Maine; David Winton Bell
Gallery, Brown University, Providence, Rhode
Island; The University of North Texas Art
Gallery, University of North Texas, Denton;
Gallery of Art, University of Missouri, Kansas
City; Milwaukee Art Museum, Milwaukee;
Sordoni Art Gallery, Wilkes University, Wilkes-
Barre, Pennsylvania; North Dakota Museum of
Art, Grand Forks; Davidson College Art
Gallery, Davidson, North Carolina; University
Gallery, University of Memphis, Memphis;
The Art Gallery, University of New
Hampshire, Durham; Kresge Art Museum,
Michigan State University, East Lansing

1995

Kiki Smith, Whitechapel Art Gallery, London; trav-
els to Galerie Rudolfinum, Prague

Kiki Smith, Sculpture & Drawings, Anthony d'Offay
Gallery, London

New Sculpture, PaceWildenstein, New York

1995–96

Kiki Smith: Photographs, PaceWildensteinMacGill,
Los Angeles; travels to
PaceWildensteinMacGill, New York

1996

Kiki Smith: Works 1988–1995, St. Petri-Kuratorium,
Lübeck, Germany

Landscape, Huntington Gallery, Massachusetts
College of Art, Boston

Field Operation, PaceWildenstein, Los Angeles

1996–97

Kiki Smith, The Montreal Museum of Fine Arts,
Montreal; travels to Modern Art Museum,
Fort Worth, Texas

Paradise Cage: Kiki Smith and Coop Himmelb(l)au,
The Museum of Contemporary Art,
Los Angeles

1997

Kiki Smith, Shoshana Wayne Gallery,
Santa Monica, California

Once I Saw a Bird, Anthony d'Offay Gallery,
London

Paper Sculpture, Prints and Multiples,
Greg Kucera Gallery, Seattle

Kiki Smith: Convergence, Irish Museum of
Modern Art, Dublin

1998

Kiki Smith: Constellation, Galerie Barbara Gross,
Munich

Kiki Smith, Metta Galeria, Madrid

Kiki Smith, The Mattress Factory, Pittsburgh

Invention/Intervention: Kiki Smith and the Museum,
Carnegie Museum of Art, Pittsburgh,
Pennsylvania

Reconstructing the Moon, PaceWildenstein,
New York

Kiki Smith: All Creatures Great and Small,
Kestner Gesellschaft, Hannover

Kiki Smith: Photographs 1997–1998,
Galerie Fricke, Berlin

1979

Doctor and Dentist Show, Colab (Collaborative
 Projects, Inc.), 591 Broadway, New York
Salute to Creative Youth, Colab, 75 Warren Street,
 New York

1980

A. More Store, Colab, 593 Broome Street, New York
Colab Benefit, Brooke Alexander Gallery, New York
Manifesto Show, Colab, 5 Bleecker Street, New York
Times Square Show, Colab, Seventh Avenue and
 41ˢᵗ Street, New York

1981

Cave Created Chaos, White Columns, New York
Teu-gum Colab, Centre d'Art Contemporain,
 Geneva
Lightning, The Institute for Art and Urban
 Resources at P.S.1, Long Island City, New York
New York, New Wave, The Institute for Art and
 Urban Resources at P.S.1, Long Island City,
 New York
White Columns, New York
Group Show, Artists Space, New York

1982

Natural History, Grace Borgenicht Gallery,
 New York
Colab in Chicago, Chicago
Fashion Moda Store, Documenta VII, Kassel,
 Germany
A. More Store, Barbara Gladstone Gallery, New York

1983

Hallwalls Contemporary Arts Center, Buffalo,
 New York
Science and Prophecy, White Columns, New York
Emergence: New Work from the Lower East Side,
 Susan Caldwell Gallery, New York
IV Theatre, organized by Büro Berlin, Berlin
Island of Negative Utopia, The Kitchen, New York

1983–84

A. More Store, Jack Tilton Gallery, New York

1984

Kiki Smith, Bill Taggert, and Tod Wizon,
 Jack Tilton Gallery, New York
Call and Response: Art on Central America,
 Colby College Museum of Art, Colby College,
 Waterville, Maine
1984: Women in New York, Galerie Engstrom,
 Stockholm
Inside/Out, Piezo Electric Gallery, New York
Modern Masks, Whitney Museum of American Art,
 New York
360 Kunst-Spiel, Wuppertal, Germany
CAYA, Buenos Aires
Synaesthics, The Institute for Art and Urban
 Resources at P.S.1, Long Island City, New York
Moderna Museet, Stockholm
Recent Acquisitions, Cincinnati Art Museum,
 Cincinnati

1986

*Hanno Ahrens, Maureen Conner, David Nelson, and
 Kiki Smith,* Art Salon, DeFacto, New York
Donald Lipski, Matt Mullican, and Kiki Smith,
 The Institute for Art and Urban Resources,
 Inc., at The Clocktower, New York
Possession is Nine-tenths of the Law, Fawbush
 Editions, New York
Public and Private: American Prints Today,
 The Brooklyn Museum, New York
Memento Mori, Centro Cultural Arte
 Contemporáneo, Polanco, Mexico
Group Invitational, Curt Marcus Gallery, New York

1987

Fawbush Gallery, New York
Emotope, organized by Büro Berlin, Berlin
Kiki Smith. Drawings, Piezo Electric Gallery,
 New York

1988

Desire Path, Schulman Sculpture Garden,
 White Plains, New York
*Committed to Print: Social and Political Themes
 in Recent American Printed Art,*
 The Museum of Modern Art, New York

A Choice, Kunstrai, Amsterdam
In Bloom, IBM Gallery, New York
Contemporary Print Acquisitions: 1986–1988,
 The Museum of Modern Art, New York
Arch Gallery, Amsterdam

1989

*Projects and Portfolios: The 25th National Print
 Exhibition,* The Brooklyn Museum, New York
Tom Cugliani Gallery, New York
Cara Perlman and Kiki Smith, Fawbush Gallery,
 New York
New York Experimental Glass, The Society for
 Art in Craft, Pittsburgh

1990

Myers / Bloom Gallery, Santa Monica, California
Portraits, The Institute for Art and Urban Resources
 at P.S.1, Long Island City, New York
The Body, The Renaissance Society at
 The University of Chicago, Chicago
Simon Watson Gallery, New York
Recent Acquisitions, The Corcoran Gallery of Art,
 Washington, D.C.
Figuring the Body, Museum of Fine Arts, Boston
Group Material: AIDS Timeline, Wadsworth
 Atheneum, Hartford, Connecticut
The Unique Print: 70s into 90s, Museum of
 Fine Arts, Boston
Fragments, Parts and Wholes, White Columns,
 New York
*Diagnosis: Marc de Guerre / Mark Lewis /
 Kiki Smith / Jana Sterbak,* The Art Gallery of
 York University, York University, Toronto
Selections from Fawbush Editions, Fawbush Gallery,
 New York
Witness Against Our Vanishing, Artists Space,
 New York
Stained Sheets / Holy Shrouds, Krieger Landau
 Gallery, Los Angeles

1990–92

The Abortion Project, Simon Watson Gallery,
 New York; travels to Holly Solomon Gallery,
 New York; Hallwalls Contemporary Arts
 Center, Buffalo

1991

Forbidden Games: Childhood, Jack Tilton Gallery,
 New York
Body, Legs, Heads … and Special Parts,
 Westfälischer Kunstverein, Münster, Germany
Drawings, Brooke Alexander Gallery, New York
Physical Relief, Hunter College Fine Arts Gallery,
 Hunter College, City University of New York,
 New York
Burning in Hell, Franklin Furnace, New York
The Interrupted Life, The New Museum of
 Contemporary Art, New York
Drawings, Susanne Hilberry Gallery, Birmingham,
 Michigan
Body Language, Lannan Foundation, Los Angeles
When Objects Dream and Talk in Their Sleep,
 Jack Tilton Gallery, New York
1991 Biennial Exhibition, Whitney Museum
 of American Art, New York
Drawing Conclusions, Guid Arte Gallery, New York
Kiki Smith / Tom Dean, Galerie René Blouin,
 Montreal
Lick of the Eye, Shoshana Wayne Gallery, Santa
 Monica, California

1991–92

*The Body Electric: Zizi Raymond and
 Kiki Smith,* The Corcoran Gallery of Art,
 Washington, D.C.

1992

Strange Developments, Anthony d'Offay Gallery,
 London
Post-Human, FAE Musée d'Art Contemporain,
 Pully/Lausanne, Switzerland; travels to
 Castello di Rivoli, Museo d'Arte Contem-
 poranea, Rivoli, Italy; Deste Foundation
 for Contemporary Art, Athens, Greece;
 Deichtorhallen, Hamburg, Germany

Désordres: Nan Goldin / Mike Kelley / Kiki Smith /
 Jana Sterbak / Tunga, Galerie Nationale du
 Jeu de Paume, Paris
This Is My Body, This Is My Blood, Herter Art
 Gallery, University of Massachusetts, Amherst
Excess in the Techno Mediacratic Society, Musée de
 Dole, Dole, France
Erotiques, A. B. Galeries, Paris
Painted Word/Written Image, Greg Kucera Gallery,
 Seattle
Byron Kim/Kiki Smith, A/C Project Room,
 New York
In Your Face, A/C Project Room, New York; travels
 to Cortland Jessup Gallery, Provincetown,
 Massachusetts
The Body, Nathalie Karg Gallery, New York
Currents 20: Recent Narrative Sculpture, Milwaukee
 Art Museum, Milwaukee
Recent Aquisitions, San Diego Museum of Art,
 La Jolla, California
Aquisitions of the 90s, Whitney Museum of
 American Art, New York
Prints, Whitney Museum of American Art,
 New York
Recent Aquisitions, The Museum of Modern Art,
 New York

1992 – 93
Corporal Politics, MIT List Visual Arts Center,
 Cambridge, Massachusetts
Signs of Life: Rebecca Howland, Cara Perlman,
 Christy Rupp, and Kiki Smith, University
 Gallery, Illinois State University, Normal

1993
Regarding Masculinity, Arthur Roger Gallery,
 New Orleans
Aperto 1993, Venice Biennale, Venice
Human Factor: Figurative Sculpture Reconsidered,
 Albuquerque Museum of Art, Albuquerque
1993 Biennial Exhibition, Whitney Museum
 of American Art, New York
PROSPECT 93, Frankfurter Kunstverein,
 Frankfurt, Germany
Drawings, Paula Cooper Gallery, New York

I Am the Enunciator, Thread Waxing Space,
 New York
Women Artists, Richard Anderson Gallery,
 New York
Art on Paper, Weatherspoon Art Gallery, University
 of North Carolina at Greensboro, Greensboro

1993 – 95
Skulptur Staat Denkmal Ausstellungsprojekt,
 Galerie Fricke, Düsseldorf

1994
Metamorphosis: Surrealism to Organic Abstraction
 1925–1993, Marlborough Graphics, New York
In the Lineage of Eva Hesse, The Aldrich Museum of
 Contemporary Art, Ridgefield, Connecticut
The Ossuary, Luhring Augustine Gallery, New York
24, Anthony d'Offay Gallery, London
Wunderkammer, Rena Bransten Gallery,
 San Francisco
World Mortality, Kunsthalle Basel, Switzerland
Some Went Mad . . . Some Ran Away, Serpentine
 Gallery, London; travels to Kunstverein
 Hannover, Hannover, Germany
Selected Works and Projects (Part One),
 Irish Museum of Modern Art, Dublin
The Essential Gesture, Newport Harbor Art
 Museum, Newport Beach, California
Miriam Cahn, Marlene Dumas, Kiki Smith,
 Sue Williams: Dessins, Centre d'Art
 Contemporain, Geneva

1994 – 95
Sculpture, Anthony d'Offay Gallery, London
The Music Box Project, Equitable Gallery,
 Equitable Center, New York
Cocido y Crudo, Museo Nacional Centro de Arte
 Reina Sofía, Madrid

1995
Division of Labor: "Women's Work" in Contemporary
 Art, The Bronx Museum of the Arts, New York
Altered States: American Art in the 90s, Forum
 for Contemporary Art, St. Louis
Body as Metaphor, Procter Art Center, Bard College,
 Annandale, New York

Summer 1995, PaceWildenstein, New York

Summer Academy 2, PaceWildenstein, New York

Body, Mind and Spirit: Eight Sculptors,
 Ruth Chandler Williamson Gallery, Scripps
 College, Claremont, California

Laboratoires pour une Expérience du Corps:
 Damien Hirst, Fabrice Hybert, Kiki Smith,
 Patrick van Caeckenbergh, Galerie Art et
 Essai, Université Rennes, Rennes, France

Féminimasculin: Le Sex de l'art, Centre Georges
 Pompidou, Paris

1995–96

In the Flesh, Freedman Gallery, Albright College
 Center for the Arts, Reading, Pennsylvania;
 travels to Aldrich Museum of Contemporary
 Art, Ridgefield, Connecticut

Exit Art / The First World, 548 Broadway, New York

The Material Imagination, Guggenheim Museum
 SoHo, New York

Time Machine, Museo Egizio, Turin

Being Human, Museum of Fine Arts, Boston

1995–97

Art Works: The Paine Webber Collection of
 Contemporary Masters, Museum of Fine Arts,
 Houston; travels to Detroit Institute of Arts,
 Detroit; Museum of Fine Arts, Boston;
 Minneapolis Institute of Arts, Minneapolis;
 San Diego Museum of Art, San Diego;
 Center for the Fine Arts, Miami

1996

The Human Body in Contemporary American
 Sculpture, Gagosian Gallery, New York

A Portrait of the Artist, Anthony d'Offay Gallery,
 London

Young Americans: New American Art in the
 Saatchi Collection — Jacqueline Humphries,
 Richard Prince, Tony Oursler, Charles Ray,
 Kiki Smith — Part 2, Saatchi Gallery, London

Selections from the Collection of Livia and Marc
 Straus, Everson Museum of Art, Syracuse,
 New York

Bodyscape, Galerie Barbara Gross, Munich

Conceal — Reveal, Site Santa Fe, Santa Fe,
 New Mexico

'La Toilette de Venus': Women and Mirrors, CRG,
 New York

Women's Work, Greene Naftali, New York

1996–97

Everything That's Interesting Is New: The Dakis
 Joannou Collection, Deste Foundation
 for Contemporary Art, Athens; travels to
 the Museum of Modern Art, Copenhagen;
 Guggenheim Museum SoHo, New York

New Persons / New Universe, Biennale di Firenze,
 Florence

Passionate Pursuits: Hidden Treasures of the Garden
 State, The Montclair Art Museum, Montclair,
 New Jersey

1997

Terra Firma, Art Gallery at The University of
 Maryland at College Park

Art and Science, The Mariboe Gallery at
 The Peddie School, Highstown, New Jersey

Surrogacy, Silhouettes, Negatives, Costumes,
 Impersonations, Disguises and Substitutions,
 Greg Kucera Gallery, Seattle

Identity Crisis: Self-Portraiture at the End of
 the Century, Milwaukee Art Museum,
 Milwaukee

1997–98

Proof Positive: 40 Years of Contemporary American
 Printmaking at ULAE: 1957–1997,
 The Corcoran Gallery of Art, Washington,
 D.C.; travels to Gallery of Contemporary Art,
 University of Colorado, Colorado Springs;
 UCLA at the Armand Hammer Art
 Museum and Cultural Center, Los Angeles;
 Sezon Museum of Art, Tokyo

BOOKS AND CATALOGS
FOR SOLO EXHIBITIONS

Tillman, Lynne and Kiki Smith. *Madame Realism.*
New York: The Print Center, 1984.

Ottman, Klaus. *Kiki Smith.* Middletown, Conn.:
Ezra and Cecile Zilkha Gallery, Center for
the Arts, Wesleyan University, 1989.

Kiki Smith. The Hague: ICA/Amsterdam,
Sdu Publishers, 1990. Texts by Paolo Colombo,
Elizabeth Janus, Eduardo Lipschutz-Villa,
Robin Winters, and Kiki Smith.

Projects 24: Kiki Smith. New York:
Museum of Modern Art, 1990.
Text by Jennifer Wells.

Kiki Smith. Chicago: Art Institute of Chicago,
Visiting Artists Program, 1991. Audio cassette
of speech given by Smith.

Rinder, Lawrence. *Kiki Smith: Matrix/Berkeley 142.*
Berkeley, Calif.: University Art Museum,
University of California at Berkeley, 1991.

Shearer, Linda and Claudia Gould. *Kiki Smith.*
Williamstown, Mass.: Williams College
Museum of Art; Columbus, Ohio: Wexner
Center for the Arts, Ohio State University,
1992. Text by Marguerite Yourcenar.

*Kiki Smith: Unfolding the Body: An Exhibition of
the Work on Paper.* Waltham, Mass.: Rose Art
Museum, Brandeis University, 1992.
Text by Susan Stoops.

Kiki Smith: Silent Work. Vienna: MAK — Öster-
reichisches Museum für angewandte Kunst,
1992. Texts by Peter Noever, Kiki Smith,
and R. A. Stein.

Kiki Smith. Humlebaek, Denmark: Louisiana
Museum of Modern Art, 1994.
Text by Anneli Fuchs.

Kiki Smith. Jerusalem: Israel Museum, 1994.
Text by Suzanne Landau.

Kiki Smith: Prints and Multiples 1985–1993. Boston:
Barbara Krakow Gallery, 1994.
Text by Nancy Stapen.

Kiki Smith. New York: Inner-tube Video, 1994.
Videocassette.

Kiki Smith. London: Whitechapel Art Gallery, 1995.
Text by Jo Anna Isaak.

Kiki Smith: Sojourn in Santa Barbara. Santa
Barbara, Calif.: University Art Museum,
University of California, Santa Barbara, 1995.
Texts by Marla C. Berns and
Elizabeth A. Brown.

Kiki Smith. New York: PaceWildenstein, 1995.

Kiki Smith. Montreal: Montreal Museum of
Fine Arts, 1996. Texts by Christine Ross and
Mayo Graham.

Smith, Kiki. *Kiki Smith's Dowry Book.*
London: Anthony d'Offay, 1997.

Kiki Smith: The Fourth Day. Destruction of Birds.
New York: PaceWildenstein, 1997.

Smith, Elizabeth A.T. *Paradise Cage: Kiki Smith
and Coop Himmelb(l)au.* Los Angeles:
Museum of Contemporary Art, 1996.

Kiki Smith: Convergence. Dublin: Irish Museum of
Modern Art, 1997. Texts by Brenda McParland
and Kiki Smith.

Kiki Smith. Pittsburgh: Mattress Factory, 1998.

Helaine Posner. *Kiki Smith.* Bulfinch / Little, Brown
and Company, Boston, New York, Toronto,
London, 1998. Text by Helaine Posner,
interview with Kiki Smith by David Fraenkel.

Kiki Smith. Madrid: Metta Galeria, 1998.
Text by Victoria Combalía.

*Invention/Intervention: Kiki Smith and
the Museums.* Carnegie Museum of Art, 1998.
Interview with Kiki Smith by Alyson Baker
and Madeleine Grynsztejn.

Kiki Smith: All Creatures Great and Small.
Hannover: Kestner Gesellschaft, 1998. Edited
by Carl Haenlein, text by Carsten Ahrens.
Scalo Zurich – Berlin – New York, 1999.

CATALOGS
FOR GROUP EXHIBITIONS

Gould, Claudia. "Interview with Kiki Smith."
 In an untitled catalogue of a group exhibition.
 Buffalo: Hallwalls, 1983.
Public and Private: American Prints Today, 24ᵗʰ
 National Print Exhibition. New York:
 Brooklyn Museum, 1986.
 Text by Barry T. Walker.
Wye, Deborah. *Committed to Print: Social*
 and Political Themes in Recent American
 Printed Art. New York: Museum of
 Modern Art, 1988.
Projects and Portfolios: The 25ᵗʰ National Print
 Exhibition. New York: Brooklyn Museum,
 1989. Text by Barry T. Walker.
New York Experimental Glass. Pittsburgh:
 The Society for Art in Crafts, 1989.
 Text by Karen Chambers.
Ackley, Clifford. *The Unique Print: 70s into 90s.*
 Boston: Museum of Fine Arts, 1990.
 Texts by Anne Havinga and Judy Weinland.
Wojnarowicz, David. *Witness Against Our*
 Vanishing. New York: Artists Space, 1990.
Drawing Conclusions. Rome and New York:
 Molica Guidarte, 1991.
 Text by Giuseppe Molica.
Whitney Museum 1991 Biennial Exhibition.
 New York: Whitney Museum of
 American Art, 1991.
Ghez, Suzanne and Joseph Scanlan. *The Body.*
 Chicago: The Renaissance Society,
 The University of Chicago, 1991.
The Interrupted Life. New York: New Museum
 of Contemporary Art, 1991.
 Texts by France Morin and Massimo Vignelli.
The Body Electric: Zizi Raymond and Kiki Smith.
 Washington, D.C.: Corcoran Gallery of Art,
 1992. Text by Terrie Sultan.
Désordres: Nan Goldin / Mike Kelley / Kiki Smith /
 Jana Sterbak / Tunga. Paris:
 Galerie Nationale du Jeu de Paume, 1992.
 Text by Catherine David.

Dissent, Difference, and the Body Politic. Portland,
 Oreg.: Portland Art Museum, Art /
 On the Edge Program, 1992.
 Texts by John S. Weber and Simon Watson.
Post Human. Pully / Lausanne: FAE Musée d'Art
 Contemporain, 1992. Texts by Jeffrey Deitch
 and Dan Friedman.
This Is My Body, This Is My Blood. Amherst,
 Mass.: Herter Art Gallery, University of
 Massachusetts, 1992. Texts by Susan Jahoda,
 May Stevens, and Elizabeth Hynes.
Über Leben. Bonn: Bonner Kunstverein, 1993.
 Text by Annelie Pohlen.
Abject Art: Repulsion and Desire in American Art,
 Selections from the Permanent Collection.
 New York: Whitney Museum of
 American Art, 1993.
 Texts by Jack Ben-Levi et al.
Whitney Museum 1993 Biennial Exhibition.
 New York: Whitney Museum of
 American Art, 1993.
The Elusive Object: Recent Sculpture from the
 Permanent Collection of the Whitney Museum
 of American Art. New York: Whitney Museum
 of American Art, 1993.
 Text by Pamela Gruninger Perkins.
Corporal Politics. Cambridge: MIT List Visual
 Arts Center; Boston: Beacon Press, 1993.
 Texts by Donald Hall, Thomas Laqueur, and
 Helaine Posner.
Hair. Sheboygan, Wisc.: John Michael Kohler
 Arts Center, 1993. Text by Alison Ferris.
The Human Factor: Figurative Sculpture
 Reconsidered. Albuquerque: The Albuquerque
 Museum, 1993. Texts by Ellen Landis,
 Christopher French, and Kathleen Shields.
Aperto '93: Emergency/Emergenza, Flash Art
 International. (XLV Biennale di Venezia.)
 Milan: Giancarlo Politi Editore, 1993.
 Texts by Achille Bonito Oliva et al.
Signs of Life: Rebecca Howland, Cara Perlman,
 Christy Rupp, and Kiki Smith. Normal,
 Ill.: University Galleries of Illinois State
 University, 1993. Text by Barry Blinderman.

The Essential Gesture. Newport Beach, Calif.:
 Newport Harbor Art Museum, 1994.
 Text by Bruce Guenther.
In the Lineage of Eva Hesse. Ridgefield, Conn.:
 The Aldrich Museum of Contemporary
 Art, 1994. Texts by Mel Bochner and
 Elizabeth Hess.
Body, Mind, and Spirit: Eight Sculptors.
 Claremont, Calif.: Ruth Chandler Williamson
 Gallery, Scripps College, 1995.
 Text by Mary Davis MacNaughton.
Bradley, Jessica. *Kiki Smith.* Toronto:
 Power Plant — Contemporary Art Gallery
 at Harbourfront Centre, 1995.
*Division of Labor, "Women's Work" in Contemporary
 Art.* New York: Bronx Museum of the
 Arts, 1995. Texts by Jane C. Delgado et al.
*Laboratoires pour une Expérience du Corps:
 Damien Hirst, Fabrice Hybert, Kiki Smith,
 Patrick von Caeckenbergh.* Rennes, France:
 Galerie Art et Essai, Université Rennes, 1995.
Terra Firma. College Park, Md.: The Art Gallery,
 University of Maryland, 1997.
 Text by Mary Jo Aagerstoun.

Kestner Gesellschaft

Goseriede 11

D-30159 Hannover

Phone 49/511/701 20-0

Fax 49/511/701 20-20

Members of the Board:

Dr Wolfgang Wagner, Honorary Chairman

Wilhelm Sandmann, Chairman

Dr Klaus F. Geiseler, Vice-Chairman

Christian Knoke, Treasurer

Klaus Stosberg, Secretary

Dr Manfred Bodin

Prof Dr Werner Schmalenbach

Advisory Board:

Lorenz Bahlsen

Dr Michael Borkowski

Prof Dr Carsten P. Claussen

Burghard Freiherr von Cramm

Dr Alexander Erdland

Angela Kriesel

Dr Peter Raue

Dr Insa Sikken

Rolf Weinberg

Director:

Dr Carl Haenlein

Kiki Smith — All Creatures Great and Small
September 26 – November 15, 1998
Catalogue 5/1998,
edited by Carl Haenlein,
Kestner Gesellschaft

Exhibition: Kiki Smith, Carsten Ahrens, Carl Haenlein
Exhibition office: Mairi Kroll, Natascha Ahrens
Technical staff: Jörg-Maria Brügger,
Norbert Schaft, Guido Bode, Dieter Günther
Assistant to Kiki Smith: Joey Kötting

Editor for the catalogue: Carsten Ahrens
Collaborating editor: Tobias Bauer
Translation: Michael Stoeber, Dermot McElholm
Editing: Alexis Schwarzenbach
Design: Hans Werner Holzwarth, Berlin
Photographs:
cover, endpapers p. 20/21, 32,: Ellen Page Wilson,
courtesy PaceWildenstein
p. 17: Raimund Kummer, Büro Berlin
p. 22/23: Greg Heins
p. 24/25: Courtesy Mattress Factory, Pittsburgh
p. 26: Paula Goodman
p. 41: Courtesy Anthony d'Offay Gallery
p. 42–82, 84–88: Attilio Maranzano
p. 83: Peter Gauditz
Scans and printing: Th. Schäfer, Hannover
Bindery: S. R. Büge, Celle

Head office: Weinbergstrasse 22a,
CH-8001 Zurich/Switzerland,
phone 41/1/261 0910, fax 41/1/261 9262,
e-mail publishers@scalo.com, website www.scalo.com
Distributed in North America by D.A.P.,
New York City; in Europe, Africa and Asia by
Thames and Hudson, London; in Germany,
Austria and Switzerland by Scalo.

First Scalo Edition 1999
ISBN 3-908247-04-7
Printed in Germany

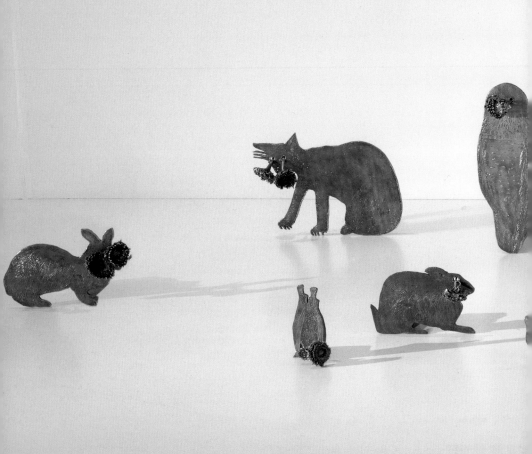